The Pre-Raphaelites and their World

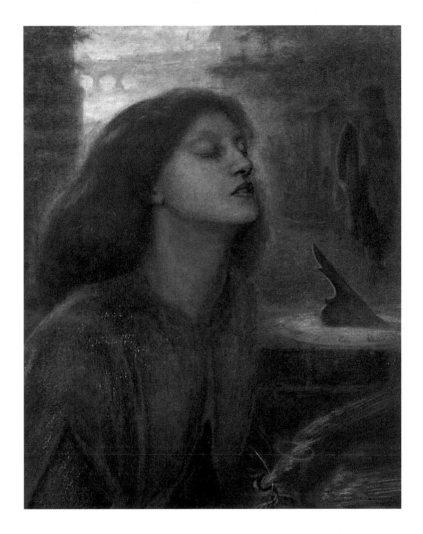

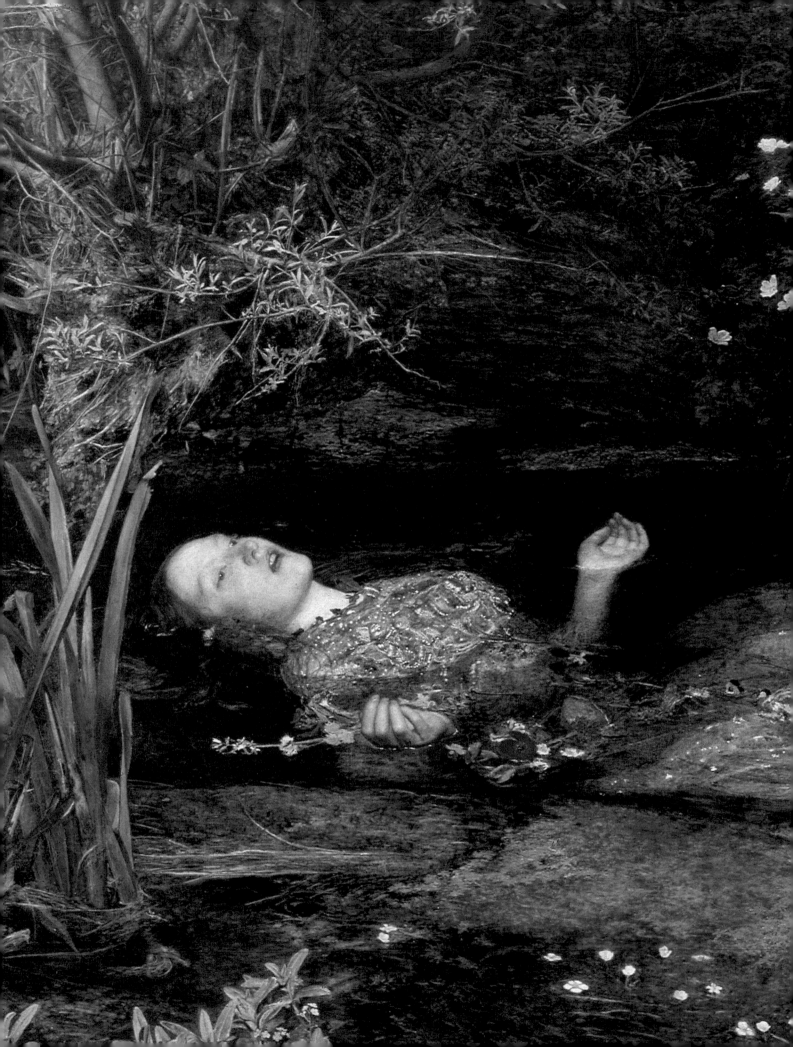

The
Pre-Raphaelites
and
their World

RACHEL BARNES

TATE GALLERY PUBLISHING

Published by order of the Trustees 1998
© Rachel Barnes 1998
All rights reserved
The moral rights of the author have been asserted
Reprinted 2001

Published by Tate Gallery Publishing Ltd
Millbank, London SW1P 4RG

ISBN 1 85437 220 3

A catalogue record for this book is available from the British Library

Designed and typeset by Roger Davies

Printed and bound in Belgium by Snoeck, Ducaju & Zoon

front cover
Dante Gabriel Rossetti, *Proserpine*, detail (see p.51)

page 1
Dante Gabriel Rossetti, *Beata Beatrix*, detail (see p.49)

page 2
John Everett Millais, *Ophelia*, detail (see p.63)

Contents

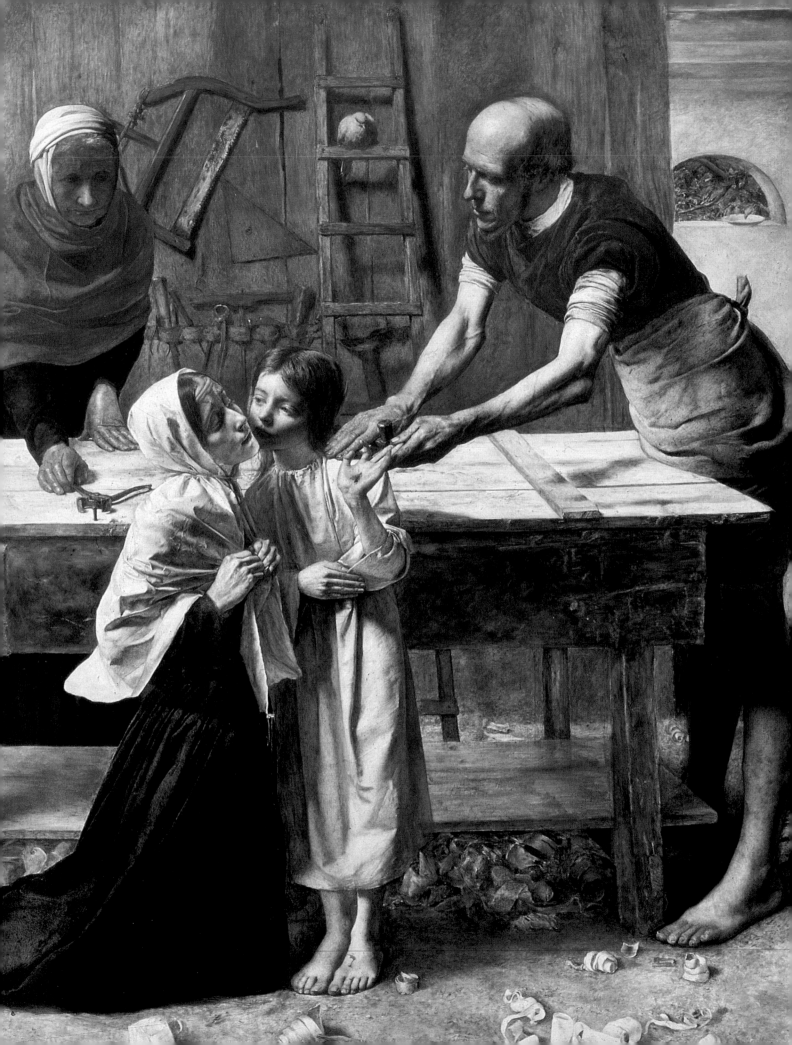

Introduction

JOHN EVERETT MILLAIS
Christ in the House of His Parents,
detail (see p.61)

THE FORMATION of the Pre-Raphaelite Brotherhood in 1848 by seven artists, including Dante Gabriel Rossetti, William Holman Hunt and John Everett Millais, was the starting point for a movement which had a profound effect on Victorian art. The Pre-Raphaelites sought to rescue art from the triviality and sterility into which they believed it had fallen and make it an expression of social and political commitment. This was combined with a passion for the literature and art of the fourteenth century – before Raphael (1483–1520) – which seemed to mirror their own aims. As a result of all these ideas, works with a contemporary social or political message were produced alongside nostalgic paintings inspired by literature or medieval legend. Modern realism, which in Paris was expressed by Manet and lead to Impressionism, was in Britain linked with a passion for romantic literature and medieval art.

This book examines the aspirations and achievements of the Pre-Raphaelites. It shows why their works, revolutionary in spirit and technique, and initially reviled in their own day by an uncomprehending public, now appear to us romantic and escapist. From what were the Pre-Raphaelite painters and poets escaping? William Morris expressed this essential Pre-Raphaelite spirit in his poem, *The Earthly Paradise* (1868–70):

> Forget six counties overhung with smoke
> Forget the snorting steam and piston stroke
> And dream of London, small, and white and clean.

It is essential to set their work in the context of a deeply materialistic, industrial age. Art often had little place in a competitive, class-ridden society where the work ethic ruled. If this sounds not unlike recent history, it may go some way to explaining the huge revival of interest in Pre-Raphaelite art during the last decade.

The Royal Academy

In 1563 Giorgio Vasari, the Italian artist and art historian, helped found the first academy of fine art in Florence under the patronage of the powerful Cosimo Medici and with Michelangelo as the first president. The motive was to promote 'fine' or 'high' art as a superior profession to the medieval craft guilds. Over the next two hundred years academies of art were founded all across Europe.

The Royal Academy of Arts in London was founded in 1768, with Sir Joshua Reynolds (1723–92) as its first president. It was the intention of the academicians and the great English portraitist to raise the profile of British painters. Reynolds achieved this by introducing royal patronage, a school offering a proper professional training and exhibitions of an improved standard to those at the Society of Artists, which had preceded the Academy. One of his major contributions to the Academy was a series of fifteen *Discourses* which he delivered at intervals between 1769 and 1790. His great aim was to found a British school of history painters.

The Royal Academy undoubtedly achieved its goal of raising the status of artists in Britain, but by the mid-nineteenth century the academic tradition had degenerated into tired conventions. In Paris Manet challenged these conventions with his painting of Olympia, where the classical nude is represented by a Parisian prostitute. And in Britain it was the rebellious stance of three young students of the Royal Academy, Rossetti, Hunt and Millais, who disliked its conventional teaching, which resulted in that uniquely British school of painting – the Pre-Raphaelite Brotherhood.

John Ruskin

John Ruskin, though still only in his twenties when the Brotherhood formed in 1848, was beginning to gain a reputation as an art critic of considerable importance. His influence was to have some bearing on the future of the Pre-Raphaelites, as he was in a position to be taken seriously when he sprang to their defence and became their champion. The art world looked with new respect on these unconventional artists. Before this Holman Hunt, in despair of ever achieving recognition, had even considered emigrating. Ruskin was also able to ease Rossetti's early years of extreme poverty by his patronage and support.

Before the main members of the Brotherhood had even met, Ruskin

JOHN EVERETT MILLAIS
John Ruskin 1853–4
Private Collection

This was painted while the artist
was on holiday with the Ruskins in
Glenfinlas, Scotland (see p.58).
Ruskin's book *Modern Painters* was
a major influence in the early days
of the Brotherhood.

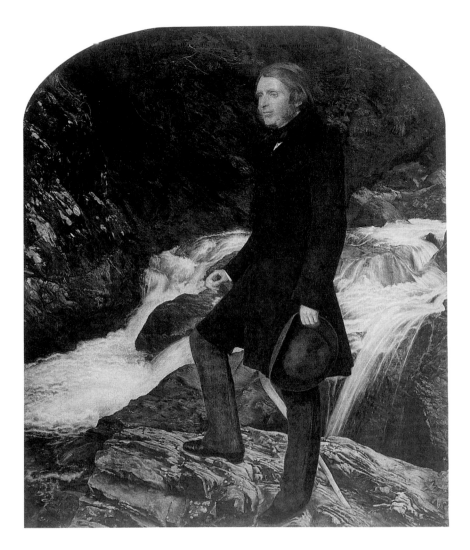

was a crucial figure in the early formation of their ideas and inspirations.
It was undoubtedly Hunt who in 1847 had read the critic's second volume of *Modern Painters* (1846) most avidly. The first volume, in praise
of the landscape painter J.M.W. Turner, did not especially impress him,
but one single phrase in the second volume immediately excited his
interest: 'Go to nature,' was Ruskin's message, 'rejecting nothing, selecting nothing and scorning nothing.'

Hunt, like Ruskin, came from an evangelical background. This is one
of the reasons why he strongly identified with Ruskin's exhortations and
felt a sense of mission in the critic's passionate love of nature. Hunt was
especially fired by Ruskin's description of Tintoretto's *Annunciation of the
Virgin* (part of a series painted 1565–87) in the Scuola di San Rocco,
Venice, in which Ruskin emphasised the importance of every realistic

detail containing a specific symbolic meaning. Although Ruskin was writing about the Renaissance in Venice, Hunt immediately saw the potential of applying these ideas to the modern-life subject (see p.21).

Hunt was enthralled with all he read. Later he wrote: 'To get through the book, I sat up most of the night and I had to return it ere I made acquaintance with a quota of the good there was in it. But of all the readers none could have felt more strongly than myself that it was written expressly for him.' The following passage impressed him especially: 'And therefore there is not any greater sign of want of vitality and hopefulness in the schools of the present day than that unhappy prettiness and sameness under which they barter in their lentil thirst, all the birthright and power of nature: which prettiness cannot but be revolting to any man who has his eyes, even in a measure, open to the divinity of the immoral seal on the common features that he meets in the highways and hedges hourly and momentarily.'

The Formation of the Brotherhood

It was Dante Gabriel Rossetti (1828–82), with his Italian sense of the *cosa nostra*, or secret fraternity, who was most responsible for the initial formation of the Pre-Raphaelite Brotherhood, or the PRB as it quickly became known. William Holman Hunt (1827–1910), John Everett Millais (1829–96) and Rossetti had met as students at the Royal Academy Schools in 1848. Their class backgrounds differed vastly, they were totally divergent as personalities and talented in very different ways, but, unquestionably, they were talented.

They were united, however, in their dissatisfaction with the traditionalist methods of teaching at the Royal Academy. They were essentially a rebellious group, fiercely rejecting what they believed to be the Academy's outmoded insistence on the importance of Renaissance ideals. The Academy held Raphael in particular to be the greatest example to artists of harmony and balance. The first president, Sir Joshua Reynolds, whom the Pre-Raphaelites irreverently renamed 'Sir Sloshua', was especially reviled for his conservatism.

The name Pre-Raphaelite Brotherhood was partly chosen to express the group's dislike of this uncritical adulation of Raphael. Hunt later remembered how on one occasion in his student days he made so bold as to criticise the venerated Raphael openly. 'Then, you are a Pre-Raphaelite,' he was told by a fellow student. 'Referring to this as we worked side by side,

WILLIAM HOLMAN HUNT
The Light of the World 1851–3
Keble College, Oxford

Nicknamed the 'High Priest' of the movement, Hunt often took religious and moral issues as his subjects. This painting became extremely well known to the Victorian audience.

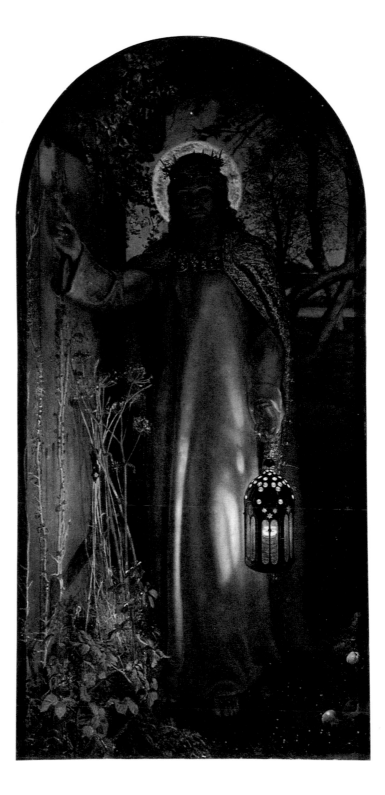

Millais and I laughingly agreed that the designation must be accepted.' Even more rebelliously, Millais wrote that Raphael's *Transfiguration* (1517–20) was 'a painting which should be condemned for its grandiose disregard of the simplicity of truth, the pompous posturing of the Apostles, and the unspiritual attitudinizing of the Saviour'. Hunt, Millais and Rossetti preferred to draw inspiration from art before Raphael, both from Italy and northern Europe. The flat clear colours, linearity, sharp outlines and luminosity of their early paintings reflect this.

There was also a concerted attempt in the early years, later abandoned, to imitate the technique of the fourteenth-century Italian fresco painters who painted directly onto wet white plaster. Hunt and Millais tried painting on to a canvas primed with wet white oil paint but had to admit that it resulted in a 'hopeless mess'. Their choice of brilliant, vivid hues, often of contrasting greens, purples and reds, was also an attempt to relate to the early Italian fresco painters.

Six members of the original seven that made up the Brotherhood were students from the Royal Academy schools, although only Hunt, Millais and Rossetti were destined to play an active part in the future of the movement. Rossetti was keen to have seven in the group as it was a number for him which had mystical associations. The other members were James Collinson (1825–81), a painter who had converted to Catholicism and was at that time engaged to Rossetti's sister, the poet Christina Rossetti (1830–94); Frederick George Stephens (1828–1907), later to become an art critic; and the sculptor Thomas Woolner (1825–92). He, like Collinson, played a lesser role in the activities of the Brotherhood. William Michael Rossetti (1829–1919), Dante's brother, was the only member of the Brotherhood who was not an artist. He was destined to become the chief chronicler and historian of the movement. It was he who wrote down with almost child-like simplicity the aims of the Brotherhood, revealing the youthful nature and ideas behind the enterprise:

1 To have genuine ideas to express;

2 to study Nature attentively, so as to know how to express them;

3 to sympathise with what is direct and serious and heartfelt in previous art, to the exclusion of what is conventional and self-parading and learned by rote; and

4 most indispensable of all, to produce thoroughly good pictures and statues.

Years later, Hunt, Millais and Rossetti were all to remember an inspirational evening, shortly before the formation of the Brotherhood, when they all three students poured rapturously over a volume of engravings by Carlo Lasinio after the fourteenth-century frescoes by Gozzoli of the Campo Santo in Pisa, united in their passion at what they saw. At the very first meeting of the Brotherhood in the summer of 1848 at Millais's studio in Gower Street, round the corner from the British Museum, more shared enthusiasms became clear. They made a list of what they called the 'Immortals', which included all their most revered historical figures. It started, promisingly enough, with Jesus Christ, at Hunt's insistence. He had deep religious convictions and was later to become known as the High Priest of the movement, as most of his works focused on Bible stories or subjects of moral controversy. Shakespeare and the author of the book of Job followed and in the third layer were twelve names: Homer, Dante, Chaucer, Leonardo, Goethe, John Keats, Percy Bysshe Shelley, King Alfred, Walter Landor, William Thackeray, Washington and Robert Browning.

John Keats was to hold a very special place in the hearts of the Brotherhood both for his romantic medievalising tendencies and for poems such as 'La Belle Dame sans Merci' (1818) with its haunting story of love leading inexorably to death. The Brotherhood especially admired this poem for its depiction of the beautiful, romantic heroine. 'Beauty is truth, truth beauty,' Keats had written in 'Ode on a Grecian Urn' (1818). This yearning for truth was also central to the Brotherhood's thinking. 'Absolute and uncompromising truth in all that it does, obtained by working everything, down to the most minute detail, from nature, and from nature only' was how they expressed this.

The rather haphazard list of Immortals is indicative of the youthful enthusiasms of the group and their as yet unformed intellectual focus. It is necessary to remember that Millais, Hunt and Rossetti were still very young (nineteen, twenty and twenty-one respectively) and as yet unsure of their artistic identity. The importance of the secrecy of the Brotherhood is perhaps still further proof of youthful ebullience. They agreed to inscribe the initials 'P.R.B.' on all their paintings, which led to many jokes and speculations. 'Penis Rather Better' or 'Please Ring Bell' were favoured as alternative explanations.

Another subject raised at these early meetings was a heartfelt cry for realism and truth in art, a reaction to the stultifying hypocrisy the Brothers saw in the mainstream art of their day. Millais and Hunt in particular

FORD MADOX BROWN
Work 1852–63
Manchester City Art Galleries

The Victorians' preoccupation with
the work ethic was reflected in the
modern-life subjects of the
Brotherhood. *Work* is a deeply
complex painting, representing the
multi-layered Victorian class
structure.

wanted to invent a new iconography which would be more relevant to
the times they lived in and to contemporary social issues. Labour, for
example, was later explored in Ford Madox Brown's *Work* (1852–63;
above) and in versions of *The Stonebreaker* by both John Brett (1857–8)
and Henry Wallis (1857). Wallis (1830–1916) also dealt with the theme
of suicide and blighted artistic aspiration in his *Death of Chatterton* (1855–6;
p.15), essentially a Pre-Raphaelite work in its careful attention to detail,
expression of sentiment and luminosity of colour. The controversial issue
of illegitimacy was tackled in Madox Brown's *'Take your Son, Sir'*
(?1851–92; p.87), and in Hunt's *The Awakening Conscience* (1853; p.79)
the taboo subject of prostitution was confronted. William Bell Scott's *Iron
and Coal* (1856–61; p.16) explored the new industrial age.

 The idea of a Pre-Raphaelite magazine as an outlet for the writings of
the Brotherhood came originally from the poet-painter Dante Gabriel
Rossetti, the most literary member of the Pre-Raphaelite Brotherhood.
'I should like gradually to include all the nice chaps we know who do any-

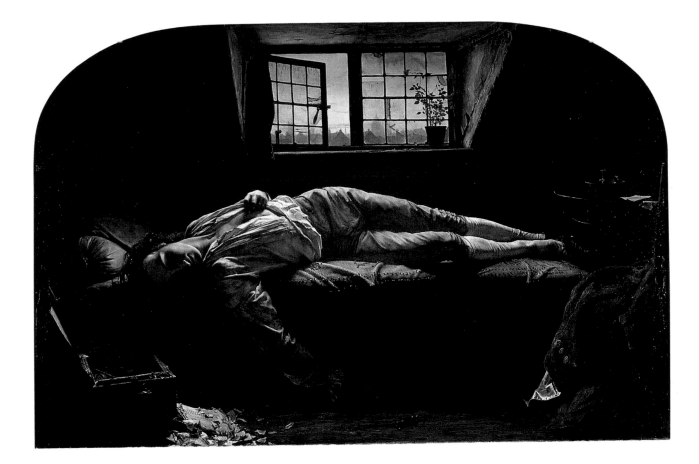

thing in the literary line,' he said, and by July 1849 the idea had gathered
momentum and was proposed as 'Monthly thoughts in Literature, Poetry
and Art'. William Rossetti, who was to be editor, recorded the first meeting on the subject. 'In the evening Gabriel and I went to Woolner's with
a view of seeing North about a project for a monthly sixpenny magazine
for which four or five of us would write, and one make an etching.'

The title that finally gained everyone's approval was 'The Germ:
thoughts towards nature in poetry, literature and art'. The magazine,
though planned initially as an outlet for Pre-Raphaelite poetry and to a
lesser extent illustration, was also an attempt to explain and elucidate
the viewpoint of Pre-Raphaelite painters – the manifesto which they had
never published. It had the immediate effect of ending the days of secrecy.

The insistence on the importance of looking at nature and recording
it painstakingly and faithfully was also central to the early aims of the
Brotherhood. The laborious botanical accuracy of such early Pre-
Raphaelite masterpieces as Millais's *Ophelia* (1851–2; p.63) and Hunt's
The Hireling Shepherd (1851–2; p.17) reflect this philosophy.

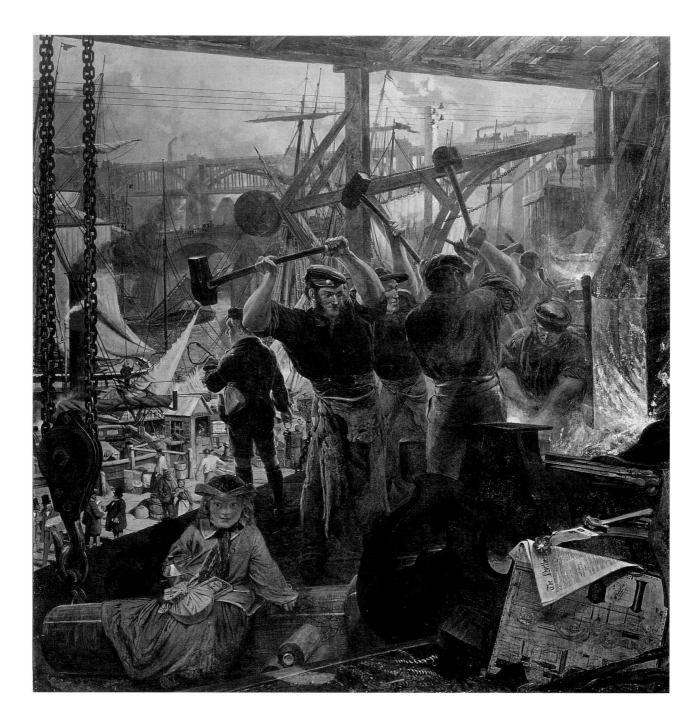

WILLIAM BELL SCOTT
Iron and Coal 1856–61
Wallington Hall, Northumberland

Far from being an example of romantic escapism like much of the work by Rossetti
(a friend of Scott's) and the other Pre-Raphaelites, this painting tackles the contemporary
theme of industrialisation.

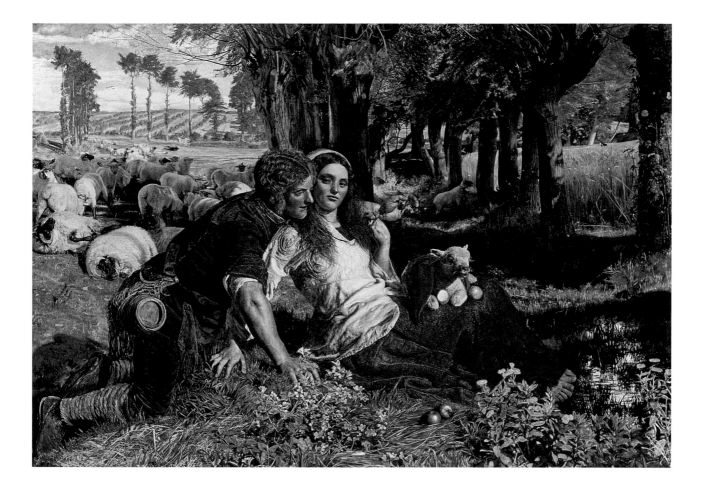

WILLIAM HOLMAN HUNT
The Hireling Shepherd 1851–2
Manchester City Art Galleries

Hunt's interest in morality and religion is expressed in this highly complex early Pre-Raphaelite painting, executed with painstaking fidelity to nature. The dalliance of the shepherd boy and girl symbolises the neglect of spiritual concerns, while the sheep, a metaphor for Christianity, are left unattended and uncared for.

After the formation of the Brotherhood in 1848, the first pictures were shown at the Academy in the following spring. Hunt exhibited *Rienzi* (1848–9), an incident from the life of the fourteenth-century Italian revolutionary Cola di Rienzi. Millais's painting, arguably the most powerful of the three, was *Isabella* (1848–9; p.19), from Keats's poem of the same name. Rossetti, who was by no means confident that the Academy would accept his work, opted to place his *Girlhood of Mary Virgin* (1848–9; p.40) at the Free Exhibition at Hyde Park Corner where space could be bought.

It was Hunt himself who recognised the originality of Millais's *Isabella*. 'It is the most wonderful painting that any youth under twenty years of age ever painted,' he wrote. Its power lies in the psychological intensity of the brother's vicious kick at Isabella's dog, in contrast with the tender gestures of the fated lovers. It is characteristic of early Pre-Raphaelitism in its use of firm outlines and brilliant luminous colours, its interest in decorative motifs and its dramatic realism.

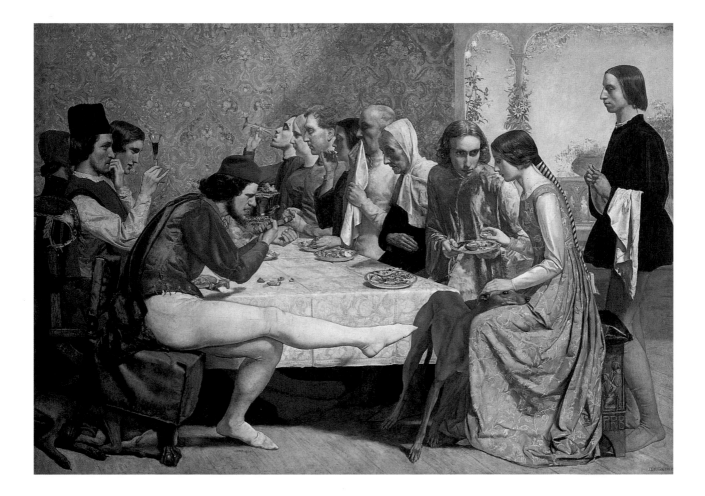

JOHN EVERETT MILLAIS
Isabella 1848–9
Walker Art Gallery, Liverpool

The subject is taken from Keats's poem of the same name, whose sinister theme of love leading to death was a recurring one with Keats and the Brotherhood.

left
WILLIAM HOLMAN HUNT
Our English Coasts, 1852 (Strayed Sheep), detail (see p.77)

Hunt spent six months working *in situ* out of doors to achieve the extraordinary botanical accuracy in this work.

The art critic of the weekly magazine the *Athenaeum* had reservations, however, about both Millais's and Hunt's paintings. 'There is so much ability and spirit in two works by men young in age and in fame mixed up with so much that is dead and obsolete in practice,' he wrote. As yet no one had noticed the initials 'P.R.B.' at the bottom of the paintings, which later would enrage critics further. But the Brotherhood's first paintings, which all sold, were received in the controversial spirit which would continue through the early years.

Much later, William Michael Rossetti summed up the atmosphere of friendship and companionship which was at the heart of the Brotherhood, and would remain so for years to come. 'We were all really like brothers, continually together and confiding to one another all experience bearing on questions of art and literature and many affecting us as individuals. We dropped using the term "Esquire" on letters and substituted "P.R.B."… There were monthly meetings, at the houses and studios of the various members in succession; occasionally a moonlight walk or

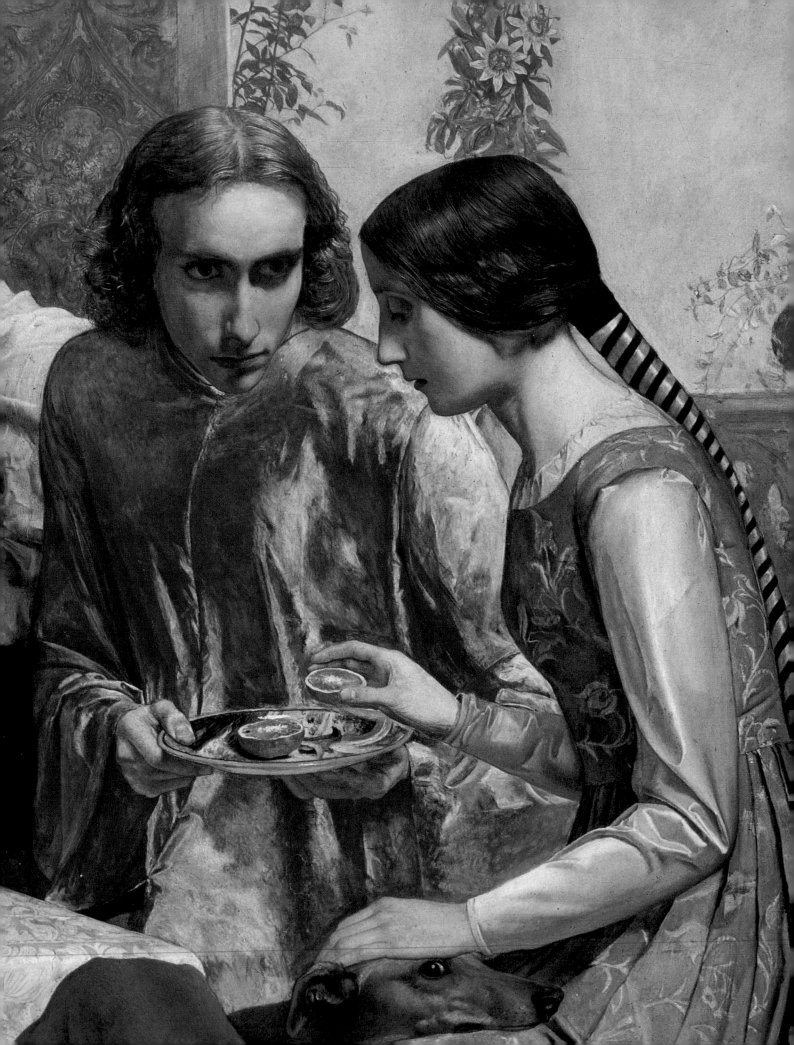

a night on the Thames. Beyond this, very few days can have passed
when two or more P.R.B.s did not gather together for one purpose or
another ... We had thoughts, our unrestrained converse, our studies,
aspirations and actual doings; and for every P.R.B. to drink a cup of tea
or coffee, or a glass or two of beer, in the company of other P.R.B.s ...
was a heart relished luxury ... Those were the days of youth, and each
man in the company, even if he did not project great things of his own,
revelled in poetry or sunned himself in art.'

The Modern-Life Subject

The modern-life subject was firmly on the agenda from the first meeting
of the Pre-Raphaelite Brotherhood in 1848. In the first issue of *The Germ*
(1850), their short-lived periodical, J.L. Tupper made an impassioned plea
against 'High art' and emphasised the need to look at contemporary life.
'Why teach us to hate a Nero or an Appius and not an underselling
oppressor of workmen and betrayer of women and children? Why to love
a Ladie in Bower, and not a wife's fireside?'

This desire to reflect everyday life in art was prevalent both in paint-
ing and literature. Charles Dickens, Anthony Trollope, George Eliot and
Mrs Gaskell were all novelists who used contemporary Victorian society
as the raw material for their writing. The French poet and critic Charles
Baudelaire visited England and became fascinated by the English and their
passion for the modern-life subject. Later, he would influence the Impres-
sionist painters with his interest in this theme.

The new and rapidly changing industrialised society is reflected in the
work of both the Pre-Raphaelite and Victorian narrative painters. By the
time the Brotherhood was formed in the 1840s, the story-telling 'prob-
lem' pictures where the viewer has to pick up clues to unravel the mean-
ing were becoming increasingly popular. The protagonists, wearing
contemporary Victorian dress, acted out dramas from everyday life. In a
sense these complex pictures were the forerunners of soap opera. Certainly
the stories were discussed and debated in the press every bit as avidly as
the characters in soap today.

William Powell Frith (1819–1909), Richard Redgrave (1804–88) and
Luke Fildes (1843–1927) were among the most important artists work-
ing in this genre. In many instances the artists were appalled by the social
problems of the day, and their work was largely motivated by a desire to
bring the worst social evils to the attention of the public. By the 1840s

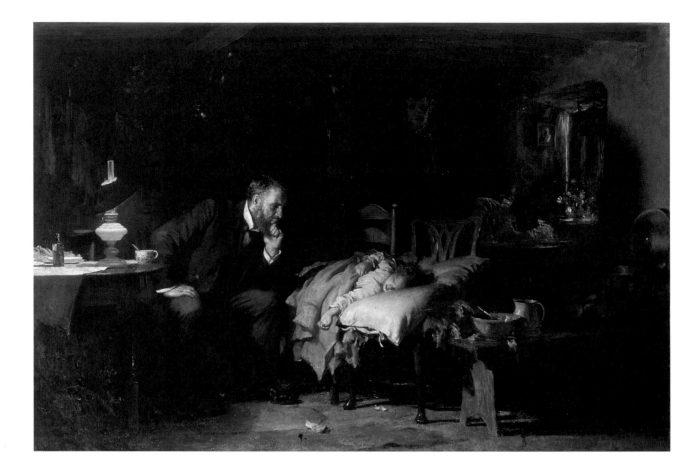

LUKE FILDES
The Doctor 1891
Tate Gallery

Commissioned by Henry Tate, this
was one of the first paintings in the
Tate collection. Fildes was inspired
to paint the subject after watching
the tireless efforts of the doctor
attending his own little boy, who
died at the age of five on
Christmas day.

and 1850s, the time the Brotherhood was formed, social problems were
at last beginning to be addressed more seriously.

Richard Redgrave's interest in pointing out social evils in his work had
initially been sparked off by an early personal trauma. His young sister,
Jane, had been sent away to be a governess. She was deeply unhappy and
subsequently caught typhoid fever and died. Later Redgrave said that he
longed 'to fight for the oppressed and weak and could only do it with his
brush'. His painting *The Governess* (1844; opposite) was one of his most
successful pictures painted in contemporary dress. It records the loneli-
ness and isolation of the governess who lives away from home, a story
that was told more dramatically in Charlotte Brontë's *Jane Eyre* (1847).
But, interestingly, Redgrave later painted other versions of this picture,
making his governess look less broken-hearted. This is reminiscent of
Dickens's rewrite of the end of *Great Expectations* (1860–61) when, due
to public pressure, he had Pip marry Estelle after all. We are reminded
that very often the Victorian audience only wanted the 'reality' of modern
life up to a point.

The Image of Women

The romantic cult of the 'stunner', the beautiful remote heroine, dominates Pre-Raphaelite painting. But there are also examples of women in less romantic predicaments. Hunt's *The Awakening Conscience* (p.79) and *The Hireling Shepherd* (p.17), Madox Brown's *'Take your Son, Sir'* (p.87) and Rossetti's *Found* (1854; p.29) bravely confront the hitherto taboo subjects of prostitution and illegitimacy.

The subject of how Victorian women are depicted in the art and literature of the period is both complex and fascinating. 'Oh that people could understand the agony of having a man's brain in a woman's body', George Eliot wrote, revealing not only her frustration with the oppression of her sex but her belief that, if a woman was clever, she must possess 'a man's brain'.

The attitude to women was, of course, deeply stereotyped. In most instances women were seen, and only really existed, in relation to men. The trilogy *Woman's Mission* (1863) painted by George Elgar Hicks illustrates this preoccupation with the image of the woman as giver and provider of support, not an independent force in her own right. The selfless, supportive qualities of women are also portrayed by the poet Coventry Patmore in *The Angel in the House* (1854–63):

A Tent pitched in a world not aright
It seemed, whose inmates, everyone,
 On tranquil faces bore the light
Of duties beautifully done.

This image of sweet passivity and tireless, selfless emotional support to the man is fleshed out in Dorothea Brooke's relationship with her egotistical husband in George Eliot's *Middlemarch* (1871–2). The filial devotion of the daughter in Dickens's *Dombey and Son* (1847–8) typifies the dutiful relationship of daughter to father, the 'paterfamilias' who must be obeyed until a husband is found.

The home and the family were at the centre of Victorian life, and Queen Victoria and Albert exemplified such middle-class family values. 'What a joy children are despite their many annoyances,' Queen Victoria wrote in her diary. The role of the woman was crucial, providing that she was dutiful and adoring, demonstrating no disturbing desire for any independence of her own.

John Ruskin wrote that home was 'a sacred place, a vestal temple, a temple of the hearth watched over by household Gods'. At the centre of this was the pure and faithful wife – an understandably difficult role for anyone with the spirit Effie Ruskin was to demonstrate (see p.58). One manifestation of this desire for purity and innocence was the white wedding, a Victorian invention explored in the later but essentially typical work by Stanhope Forbes (1857–1947), *The Health of the Bride* (1889). Alfred Tennyson, who inspired the Pre-Raphaelites but was certainly no mentor of the later Suffragette movement, wrote in *The Princess* (1847).

Man for the field and woman for the hearth,
Man for the Sword, and the needle she;
Man with the head, and woman with the heart;
Man to command, and woman to obey.

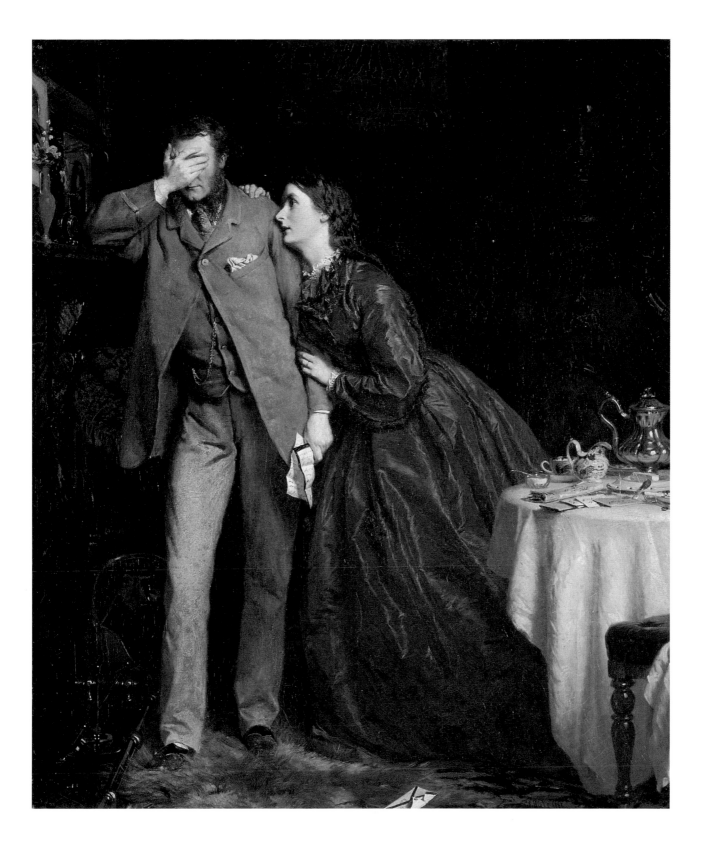

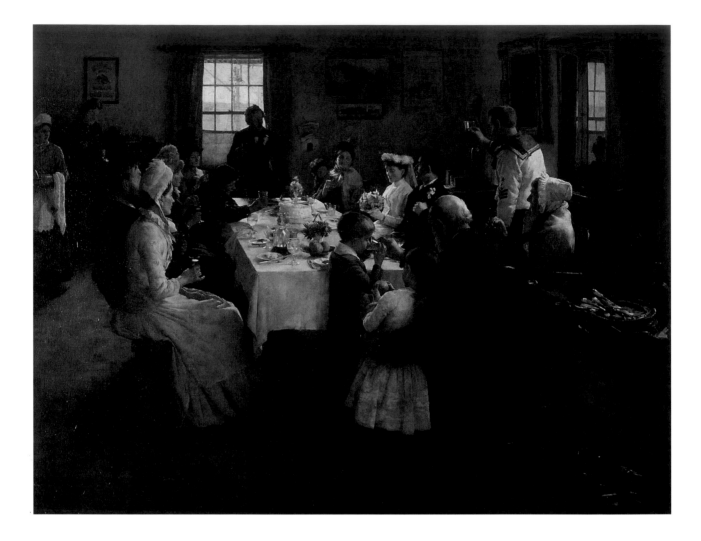

STANHOPE FORBES
The Health of the Bride 1889
Tate Gallery

Forbes painted this beautifully observed village wedding in an inn in Cornwall, where he was living at the time.

Among Pre-Raphaelite works, many of Arthur Hughes's family scenes, such as *Bedtime* (1861) and *The Woodcutter's Daughter* (1860) painted with his wife Tryphena and his own children as models, stressed the importance and almost sacred quality of family life. In Millais's *The Order of Release, 1746* (1852–3; p. 65) and Ford Madox Brown's *The Last of England* (1852–5; p.83) the woman appears primarily as a strength and support to her husband in a time of stress.

The Fallen Woman

Another very different aspect of womanhood explored in Victorian art and literature, the fallen woman, was a source of constant fascination. Both in Victorian narrative painting and Pre-Raphaelite works unfaithful wives, mistresses and prostitutes abound. 'Can the outcast retrace her

AUGUSTUS LEOPOLD
EGG
Past and Present (Nos 1 & 3)
1858
Tate Gallery

Interwoven with complex symbols and executed in minute detail, Egg's famous triptych reflects the Victorian fascination with a moral tale. In the first painting (right) the adulterous wife has been discovered, and her unforgiving husband holds the offending letter as she pleads for mercy. The second and third paintings depict events some five years later, and in the second (not illustrated) the children, now adolescents who have been left quite alone after the recent death of their father, are gazing sadly at the moon, evidently thinking of their mother. In the third painting (right) the unfaithful wife has been punished. Destitute and homeless under the arches, she too looks out at the moon and clasps her new child to her.

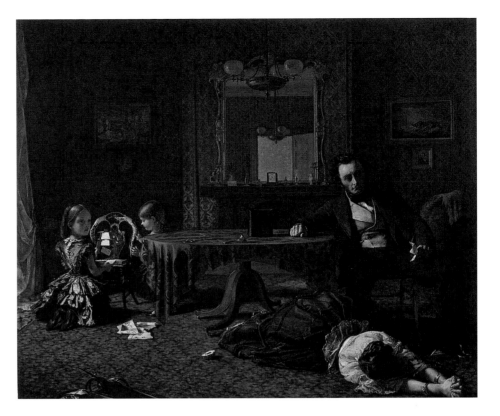

opposite

DANTE GABRIEL ROSSETTI
Found 1854
Delaware Art Museum, Wilmington, DE

This was Rossetti's only modern-life subject, which he attempted to resolve in a number of different versions. The theme of the shepherd's erstwhile girlfriend being discovered as a prostitute in the town dramatises the typical Victorian concept of rural life engendering innocence and the town harbouring evil and temptation.

steps? / Would any mourn with her although / She watered the earth with tears?' wrote William Bell Scott, a painter and poet closely associated with the Pre-Raphaelites, in his poem *Maryanne*. The grisly consequences of adultery are depicted in *Past and Present* (1858; p.27) by Augustus Leopold Egg (1816–63), a melodramatic triptych whose detailed execution and literary, story-telling nature are reminiscent of Pre-Raphaelite paintings by Hunt and Madox Brown.

The hypocrisy of double standards of morality was a repeated theme in Pre-Raphaelite pictures. Madox Brown's *'Take your Son, Sir'* (p.87), Hunt's *The Awakening Conscience* (p.79) and Rossetti's *Found* (opposite) all work the theme. Caroline Norton, a champion of women's rights and from a broken marriage herself, wrote that 'the faults of women are visited as sins, the sins of men are not even visited as faults'.

In Victorian art and literature the image of the outcast woman is usually treated with compassion and understanding. Often she becomes almost a symbol of innocent suffering. Charles Dickens, who set up a home, Urania Cottage, for reformed prostitutes, wrote movingly of the prostitutes' plight in Peggotty's search for Little Emily in *David Copperfield* (1849–50).

Perhaps the most famous fallen woman in Victorian literature is Tess of the D'Urbervilles, who suffers so cruelly in the hands of men. Hardy deals here with the subject of seduction, a not uncommon occurrence, particularly amongst girls from poor and working-class backgrounds. But Hardy went too far in the realism of his story. There was public outcry when *Tess* was published in 1891. Much earlier, Mrs Gaskell's novel *Ruth*, which was published in 1853 (the year of *The Awakening Conscience*) and deals with the subject of seduction, also caused a public outcry. In *Ruth* Mrs Gaskell showed how frequently working-class girls were victims of seduction, then subsequently ostracised by society.

There are many accounts of prostitution in London and Paris in the nineteenth century. The Haymarket at night was one of London's most notorious haunts. 'Every hundred steps, one jostles twenty harlots', wrote one observer. But the desire of the Pre-Raphaelites to paint such a subject echoed the gradual dawning of a more enlightened approach to the problem. It began to be seen more as a result of social and economic pressure than immorality. Many female workers were paid such low wages they were forced to supplement their earnings by becoming street walkers. The girls were known as 'dollymops' or 'Park doxies', as they frequently plied their trade in parks, in particular Green Park near Piccadilly. Dr William Acton, who was relatively enlightened on the subject, wrote in his book,

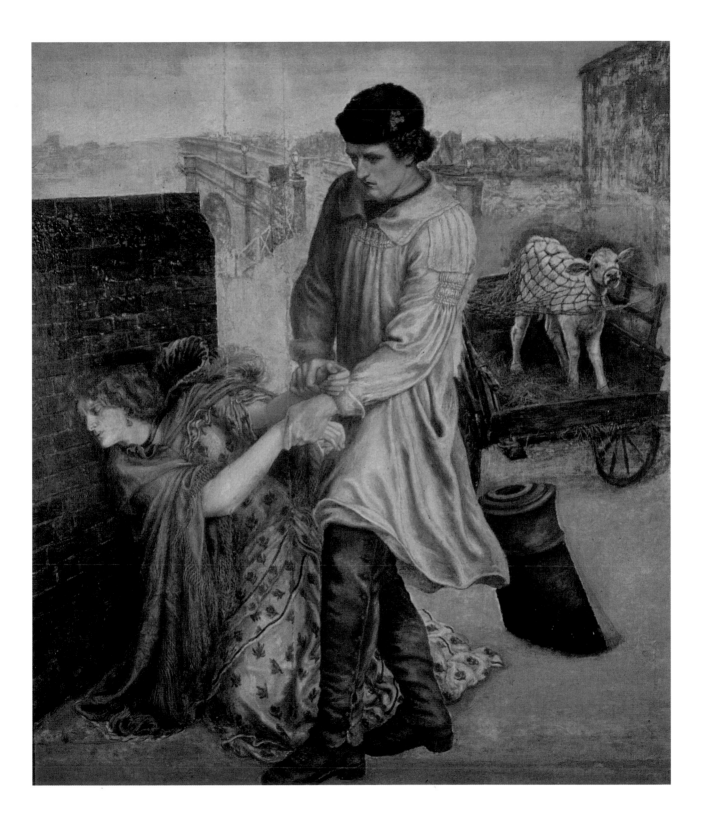

Prostitution Considered in its Moral, Social, and Sanitary Aspects, in London and Other Large Cities (1857), that 'the better inclined class of prostitutes become the wedded wives of men in every grade of society, from the peerage to the stable'.

Richard Redgrave's *The Outcast* (1857) is an archetypal Victorian scene of the righteously indignant father banishing his daughter and her illegitimate baby from the home. The family's anguished pleas fall on deaf ears, and Redgrave takes pains to make the viewer sympathise with the daughter. G.F. Watts tells the story even more simply in his chilling painting, *Found Drowned*, which depicts a suicide washed up by Waterloo Bridge, an incident the artist was supposed to have witnessed himself.

The Town

The Victorians were the creators of the modern town. By the 1850s, the time the Pre-Raphaelite Brotherhood was formed, the population of the towns had overtaken that of the country for the first time in history. During the nineteenth century England changed dramatically from a rural society into an urban one. Many of the great reformers, such as John Ruskin, William Morris and Thomas Carlyle were horrified by the changes that took place. They watched, seemingly powerless, as the great industrial cities expanded.

The Victorian Gothic Revivalist architect Augustus Pugin had strong feelings on the subject. His desire to recreate the aesthetic beauty and purity of the Middle Ages in his buildings was born out of his aversion to modernism. In his book, entitled *Contrasts* (1836), he illustrates a medieval village in 1440. Underneath he grimly juxtaposes the same location in 1840. The 'dreaming spires' have now been overshadowed by the spread of factories and housing for the workers. William Morris also wrote with deep regret about the beauty of the old world disappearing. The poet William Wordsworth embarked on a famous correspondence with *The Times* when he saw his beloved Lake District under danger from the spread of the railway.

The escapism of the Pre-Raphaelite Brotherhood, and their desire to travel back in time to the days of King Arthur and his knights, was in part a reaction to the inexorable march of time, as the effects of the Industrial Revolution took hold. Their preoccupation with landscape, influenced by Ruskin, was a part of a move, prevalent at this time, to value

nature more, as the towns and cities grew and the countryside diminished.

'Man made the Town and God made the Country' was a quite widely held premise. Significantly, in Hunt's *The Awakening Conscience* (p.79) the girl looks out towards nature (admittedly, only the trees in a square in St John's Wood) when she experiences her moment of religious revelation. Likewise, in Rossetti's *Found* (p.29) it is in the town that the girl has become a prostitute. Her former lover, a shepherd, recognises her with horror, remembering their innocent country days. The implication is clear. It is the town that has brought about her ruin.

Despite this moralistic view, there were writers and artists who celebrated the romance and mystery of the city, most especially London. 'So far from the smoke of London being offensive to me, it has always been to my imagination the sublime canopy that shrouds the City of the World,' wrote Benjamin Robert Haydon in his *Autobiography and Journals*, published in 1853. Haydon also wrote most poetically about the notorious 'smog', the fog and mist which hung over London and was frequently described by Dickens. Yet, to Haydon it was a 'sublime canopy… hanging in gloomy grandeur over the vastness of our Babylon'. It excited in him 'feelings of energy such as no other spectacle could inspire'.

The American painter James Abbott McNeill Whistler (1834–1903), who lived next door to Rossetti in Chelsea, painted some of the most memorable poetic visions of London at night. With his interest in 'art for art's sake', his self-imposed aesthetic creed, he conveys only the colours and atmosphere of the nocturnal city. We learn nothing of the social evils. He almost provides a description of one of his own paintings when he writes: 'When the evening mists clothe the riverside with poetry, the poor buildings lose themselves in the dim sky, and the tall buildings become campanili and the warehouses are palaces of the night.'

The French artist, Gustave Doré, also left a memorable image of Victorian London, when he illustrated Blanchard Jerrold's *London* (1872). The rowdiness and confusion of the bustling capital are captured in Doré's etchings of Covent Garden and Billingsgate, which are also powerfully described in Dickens's *Nicholas Nickleby* (1838–9). A strange, romantic aura hangs over the city peopled with offbeat Dickensian characters; in Doré's London 'an English crowd is almost the ugliest in the world, because the poorer classes are but copyists in costumes of the rich', writes Jerrold. But he goes on to describe Covent Garden and Billingsgate as full of 'groups of people, wonderfully tempting to the artist's eye'.

This sense of mayhem is also described in A.B. Houghton's *Holborn*

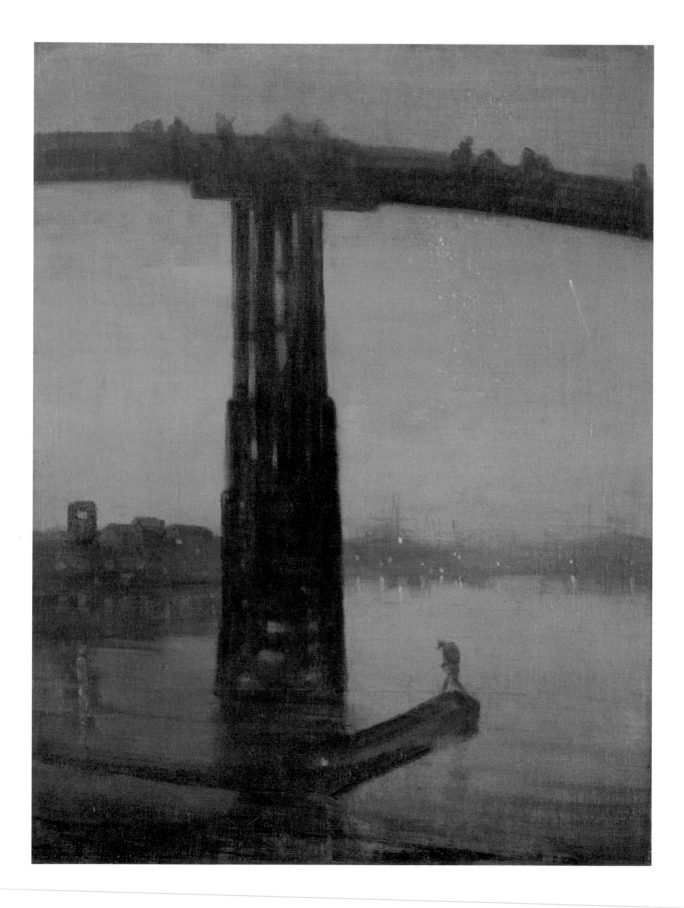

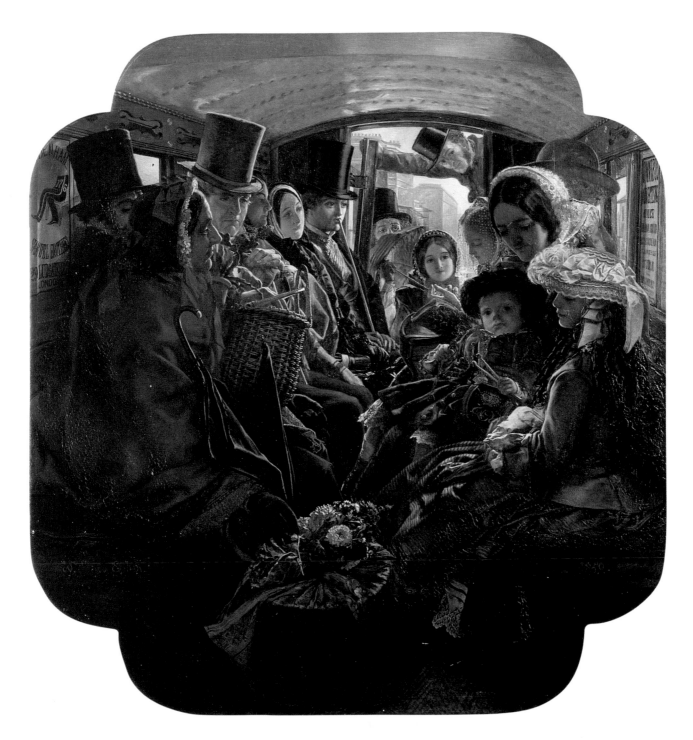

left

JAMES ABBOTT MCNEILL WHISTLER

Nocturne in Blue and Gold: Old Battersea Bridge 1872–5

Tate Gallery

The minimal palette used in this poetic vision of London demonstrates Whistler's doctrine of aesthetic values, where every colour must harmonise like the notes in a chord.

above

WILLIAM MAW EGLEY

Omnibus Life in London 1859

Tate Gallery

A number of Victorian narrative painters were drawn to the subject of crowded transport scenes. It gave an opportunity to paint the different classes in Victorian society.

(1861), in a passage which recalls the scene of busy activity in Hampstead in Ford Madox Brown's *Work* (p.14). 'The pavements are crowded; shoppers jostle with beggars and street urchins; to add to the confusion, two navvies are digging up the road, and children are playing in the piles of earth; and two overcrowded omnibuses are forcing their way through the crowds.' Another painter to be inspired by such urban scenes was William Maw Egley (1826–1916), whose *Omnibus Life in London* (1859; p.33) shows that he was developing the distinctive, hard-edged style of the Pre-Raphaelites, using shiny, contrasting colours and faithfully representing realistic detail.

The Country

Despite the huge growth of new towns and cities in Victorian England, in many small villages the pattern of life had changed little since the Middle Ages. Flora Thompson describes this simple, happy and self-sufficient life, where there is little contact with the outside world, in her retrospective, autobiographical trilogy *Lark Rise to Candleford* (1945).

There was a marked tendency in art to idealise the joys of rural existence in reaction to the Industrial Revolution. The newly wealthy middle class had town villas to decorate, and landscapes and rural scenes, of very varying quality, became *de rigeur*. Pictures of flirtations in the countryside were especially popular, providing an opportunity to paint both

WILLIAM POWELL FRITH
The Derby Day 1856–8
Tate Gallery

This hugely ambitious panorama of Victorian life was supposed to represent over a hundred different psychological types from town and country. Frith's masterpiece gives a careful account of the complex class structure, and the huge gulf between the privileged and poor.

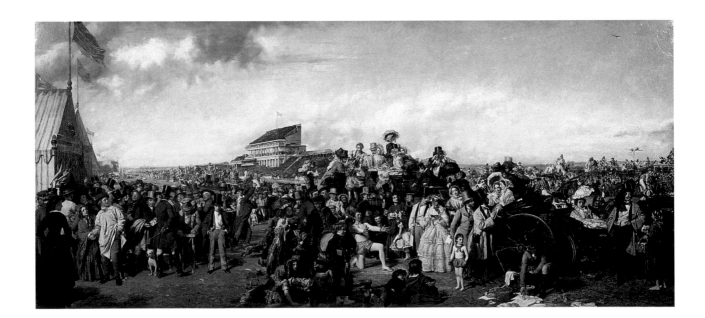

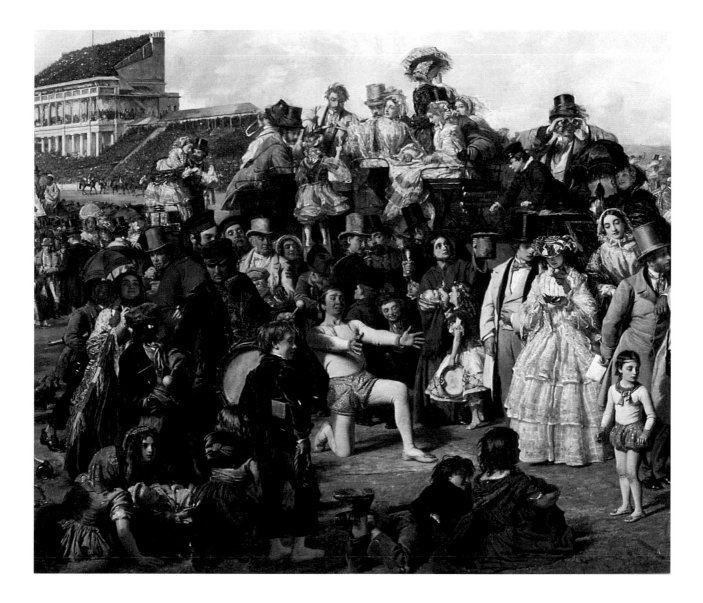

WILLIAM POWELL FRITH
The Derby Day, detail (see opposite)

Frith posed every character separately in his studio for a work which took him over a year to complete.

pretty girls and sunlit meadows. Jacob Thompson's *The Course of True Love Never Did Run Smooth* (1854) depicts a tender young couple sorting out their differences by a country stile and is typical of many such scenes. Arthur Hughes's *The Long Engagement* (c.1854–9) and *April Love* (1855–6; p.109) and Holman Hunt's *The Hireling Shepherd* (p.17), although painted with meticulous Pre-Raphaelite technique, continue this tradition of a love scene enacted amidst a lyrical, rural setting.

But for the working class life in the country was difficult, and pay for agricultural workers continued to be very low, most especially in the non-industrialised south and west. In the winter months some families went short of food. A number had only turnips to live on, the subject of

GEORGE CLAUSEN
Winter Work 1883–4
Tate Gallery

Clausen's depictions of farm workers
are realistic portrayals of the
hardships suffered by exploited
labourers during this period.

The Squire and Game Keeper attributed to James Lobley (1829–88). This
scene also emphasises England as fundamentally patrician. Social pres-
tige was still associated with ownership of land. Yet many of the great
Victorian country houses were financed by new money, made from trade
and industry. William Powell Frith's extraordinary panorama of Victo-
rian society, *The Derby Day* (1856–8; p.34), gives the viewer the oppor-
tunity to observe the complex workings of class structure, of rich and poor,
in both rural and city dwellers.

Scenes which painted a rosy and romantic view of country life, such
as *The Old Gate* (1869) by Frederick Walker (1840–75), in which rural
children were depicted as poor but happy, were most popular. The father

and his young son of about twelve return from a hard day's work in the field, but they appear to be perfectly cheerful about it. A few artists avoided this kind of cliché and painted a more honest and penetrating view of farming people. The stark image of agricultural labour in *Winter Work* (1883–4; opposite) by George Clausen (1853–1944) leaves little doubt as to the realities and hardships of badly paid, exploited farm labour. But it is significant that Clausen is active later on in the century, when there was a move to reform such exploitation. Thomas Hardy's novels set in Wessex also provide more realistic accounts of rural poverty, such as Tess's gruelling winter work in *Tess of the D'Urbervilles* (1891).

The huge numbers of Victorian landscapes, which continued to fill the sale-rooms, were uneven in quality. Indisputably, the Pre-Raphaelites with their ideal of 'truth to nature' produced the most brilliant paintings in the genre, such as Madox Brown's *Carrying Corn* (1854–5; above), but they were not alone in their desire to paint nature.

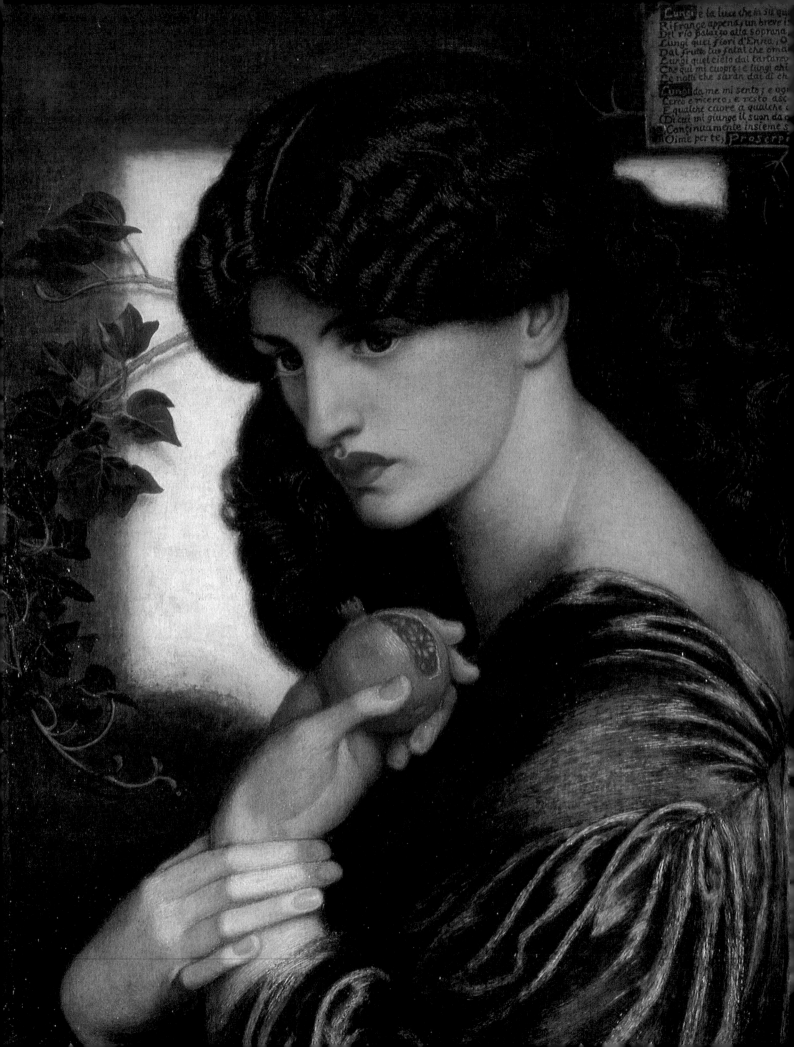

Dante Gabriel Rossetti
1828–1882

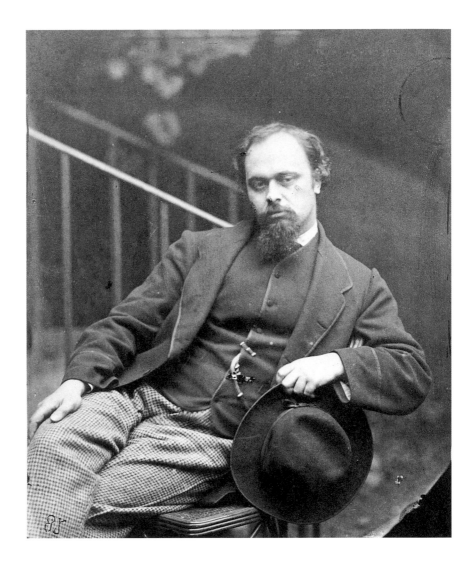

ROSSETTI'S father Gabriele Rossetti was a political exile from the Kingdom of Naples who had settled in London and become a professor of Italian. Well-known as a commentator on Dante (1265–1321), he chose to name his first-born son after the poet, and from the beginning had aspirations for the boy to become the poet he himself had failed to be.

His wife Frances Polidori was an Anglican and a woman of strong intellect and character. Her devout faith would later have an influence on her son's early Pre-Raphaelite work. As a woman of over seventy, she wrote: 'I have always had a passion for intellect and my wish was that my husband should be distinguished for intellect and my children too. I have had my wish; and I now wish that there was a little less intellect in my family, so as to allow for a little more common sense.'

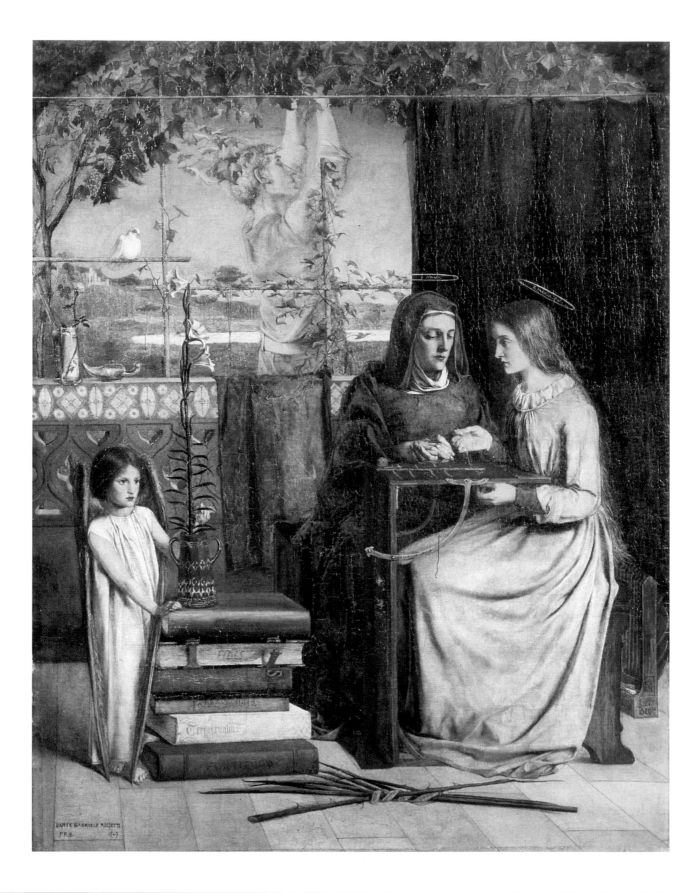

Although her eldest son showed considerable talent as both poet and painter from early childhood, common sense was never a characteristic. His father nicknamed his four children 'the calms and the storms'. Dante Gabriel and his sister Christina were the volatile, temperamental ones – the storms – whilst the eldest girl Maria and the younger brother William Michael were more stable. Gabriel's wild and self-destructive tendencies did not diminish over the years.

The Rossetti household was bohemian and cosmopolitan, remembered later by members of the Brotherhood as being frequently filled with Italians eating macaroni and talking excitedly about poetry and politics. Brought up in this literary atmosphere, Dante Gabriel found it difficult to decide whether to devote himself to poetry or painting, though it was always said within the family that 'Gabriel means to become a painter'.

In the event, he was to pursue the two disciplines, which became both his strength and his weakness. But his impatience with the drudgery of artistic training prevented him from acquiring the technical mastery which so distinguished the work of his fellow Brothers, Hunt and Millais. Although he entered the Royal Academy Schools in 1844, his approach to his studies was somewhat dilettante, and he spent much of his time reading and illustrating poetry.

Christina Rossetti shared her brother's infectious enthusiasm for the Pre-Raphaelite Brotherhood. In her famous, instantly successful poem of 1857, *Goblin Market*, illustrated by her brother, the aura of magical, fairy-tale escapism shows sympathies with the Brotherhood's predilection for vivid, colourful story telling. Her passionate, sensuous love poems also relate to the later phase of her brother's work. But when Dante Gabriel suggested that his talented sister might in some way take part, the notion was rejected out of hand. The Brotherhood was to remain intact; sisters did not belong.

Dante Gabriel's tender, romanticised portraits of his family and lovers are a window into an enclosed, poetic world of the imagination. The harsh reality of the real world had no place either in his art or in the poetry of Christina. She is the model for the Virgin Mary in both his early, awkward Pre-Raphaelite works, *Ecce Ancilla Domini! (The Annunciation)* (1849–50) and *The Girlhood of Mary Virgin* (1848–9; opposite), when he was struggling with composition which came so naturally to Hunt and Millais. Christina's forlorn, secretive face was perfect for the adolescent Virgin Mary, a painting subsequently savaged by the critics. 'Christina – the isolation of a bird, remote, minute and distinct', her brother wrote.

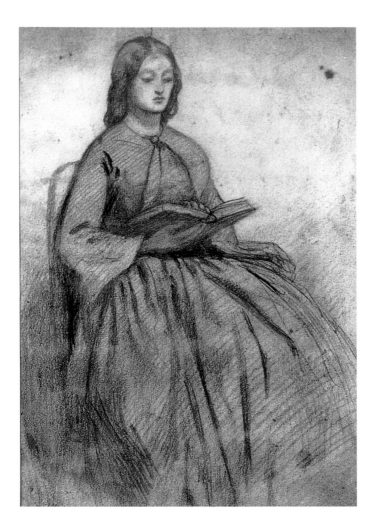

His beautiful, sensitive drawings of her emphasise her intense introspec-
tion. Idealising her dreaming face, he made her his first Pre-Raphaelite
queen, before the golden-haired Elizabeth Siddal eclipsed all others.

It was Walter Deverell, the aspiring painter, closely associated with the
Brotherhood until his early death, who is always credited with 'discov-
ering' Elizabeth Siddal in 1849, then a girl of seventeen, working in a
milliner's shop in Cranbourne Street in Covent Garden. By this time the
Brothers were very much on the look out for 'stunners' – beautiful, romantic-
looking women who could model for them. Lizzie's ethereal beauty
was inspirational to them and she soon became well known in the stu-
dios, sitting for Hunt's *Converted British Family Sheltering a Christian Mis-
sionary* and, more famously, for Millais's picture of Ophelia, floating down
the river to her death. Deverell wrote of her: 'She was tall and slender,
with red coppery hair and bright consumptive complexion, though in

these early days she had no striking signs of ill health. She was exceedingly quiet, speaking little. Her drawings were very beautiful, but without force.' Rossetti adored her. At the age of twenty-two he fell in love with her in an intensely romantic way, and for the next five years she became the focus of all his art. She was the Beatrice to his Dante – Dante had fallen in love with a girl who appears as 'Beatrice' in his poetry, and was stricken by her death in 1290. In Rossetti's last painting of Elizabeth, a memorial to his dead wife after her suicide, he called her 'Beata Beatrix' (see p.48).

As a poet-painter who saw himself rather as Dante reincarnate, Rossetti had little patience with the tedious exercises of copying in oil direct from nature which preoccupied his fellow Brothers. His watercolours inspired by Dante and Arthurian legend are small-scale paintings, stippled layers of intense colour. A blend of poetic medievalism and romantic archaism prevails. 'These chivalrous … themes are quite a passion of mine,' he wrote.

Lizzie, with her ethereal beauty, became his muse and inspiration in drawings and watercolours until she was later replaced by his passion for the dark, sensual looks of William Morris's wife, Janey. But initially Rossetti never tired of sketching Lizzie – or 'Guggums', as he called her – making over sixty sketches of her reading, sitting, dreaming, always distant and unattainable. 'It is like a monomania with him,' wrote Ford Madox Brown, after visiting his studio. 'Many of the drawings are matchless in beauty.' Even when painting other subjects, Rossetti only depicted Lizzie's face. Lizzie was herself an artist and the two of them benefited from Ruskin's patronage. In these early poverty-stricken years when Rossetti was not exhibiting his work, this was a crucial means of support.

Christina understood her brother's passionate, obsessive nature better than anyone. It mirrored her own. 'One face looks out from all his canvases,' she writes in her poem 'In An Artist's Studio'. She knew that her brother had turned Lizzie into the vision he wanted. 'Not as she is, but was when hope shone bright; Not as she is, but as she fills his dreams.' Christina saw that no one could sustain this romantic idyll, that it would end badly.

By the time Rossetti married Elizabeth in 1860, she was seriously ill and he had already resumed his philandering. But when she committed suicide with an overdose of laudanum in 1862, he grieved deeply, blaming himself, not entirely inaccurately, for her death. He buried the only copy of his poems with her as a supreme act of self-sacrifice – one that

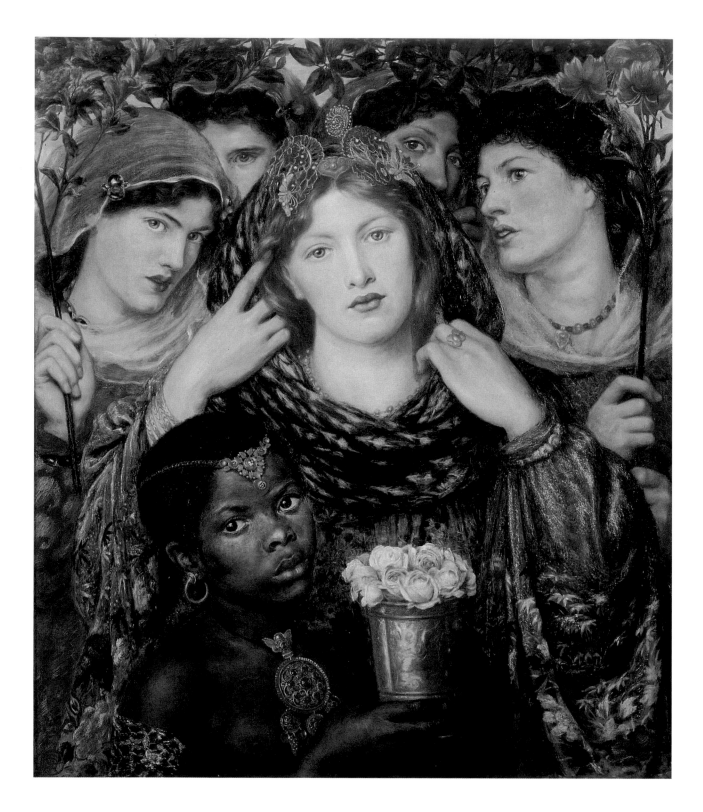

he was unable to sustain. Notoriously, he had his wife's grave exhumed seven years later in order to publish his *Poems* in 1870, which were sav agely criticised as being of 'the fleshly school of poetry'.

After Lizzie's death Rossetti lived in Chelsea where he was a neighbour and friend of the painter Whistler. His later oil paintings of sensuous female figures, influenced by the art of the Venetian Renaissance, were important in the development of the 'art for art's sake' Aesthetic movement derived from the French poets and art critics Théophile Gautier and Charles Baudelaire. His models included the beautiful Alexa Wilding and his mistress Fanny Cornforth, but his new muse after Lizzie's death, or a little before, was the archetypal Pre-Raphaelite 'stunner', the raven-haired Jane Burden, who had married the artist and designer William Morris in 1859. The more cynical biographers suggest that Rossetti had encouraged the marriage in order to keep Janey, with whom he was already enamoured, within the circle.

Either way, by 1869 Janey and Rossetti were lovers with Morris's sad acquiescence. They lived together at Kelmscott Manor, near Lechlade on the upper Thames, which Rossetti and Morris had bought as a joint tenancy. Rossetti, always at his best when inspired by love, painted Janey obsessively in many different guises.

His last years were a sad decline into increasing alcoholism, drug addiction and mental instability, a form of paranoia from which his father had also suffered. Although he continued to paint and write up until his death, his existence became increasingly hermetic. Edward Burne-Jones later wrote of the melancholy of the last 'ghostly evenings' he sometimes spent with Rossetti when he seemed to have 'given it all up and will try no more'. 'Look in my face, my name is Might-have-been; I am also called No-more, Too-late, Farewell' was how the artist described his own sad demise in 1870 in his poem 'A Superscription'.

Although Rossetti was instrumental in founding the Brotherhood and his creative energies were the most original, his early work was untypical of the predominant interests in nature and modern life shared by the other Brothers. He was not excited by either; his only sortie into the modern-life subject, entitled *Found* (1854; p.29), caused him much pain and worry and was ultimately abandoned. He was essentially an individual painter, inspired by an inner poetic vision. But his passion for medieval stories and legends was another side of Pre-Raphaelitism, and his later work, after 1860, created a new phase which was to have an important influence on William Morris and Edward Burne-Jones.

DANTE GABRIEL ROSSETTI

Dante's Vision of Rachel and Leah 1855

Tate Gallery

This watercolour, for which Elizabeth Siddal sat, illustrates a passage from Dante's *Purgatory* from *The Divine Comedy*. It was commissioned by John Ruskin and painted during the 1850s when Rossetti was mostly preoccupied with subjects from Dante, using Lizzie as model. The attention to plants in the foreground, not usually of great interest to the artist, might well have been in deference to the critic's passion for fidelity to nature. The honeysuckle and rose in Leah's hair held connotations of sexual attraction for Rossetti. Ruskin was very happy with the small-scale work and especially the delicate use of colour. He wrote: 'The colour of the purple robe – and the stonework and honeysuckle flower-colour – renders the picture unique as far as I know in some points of colour – so strangely delicate and scented. I think very lovely.'

The passage from Dante's *Purgatory* reads:

> A lady young and beautiful, I dream'd,
> Was passing o'er a lea; and, as she came,

> Methought I saw her ever and anon
> Bending to cull the flowers; and thus she sang;
> 'Know ye, whoever of my name would ask,
> That I am Leah; for my brow to weave
> A garland, for these fair hands unwearied ply.
> To please me at the crystal mirror, here
> I deck me. But my sister Rachel, she
> Before her glass abides the livelong day
> Her radiant eyes beholding, charm'd no less,
> Than I with this delightful task. Her joy
> In contemplation, as in labour mine.'

Whilst Leah symbolises the active life by wearing green, the colour of life, her sister Rachel represents the contemplative life. Rossetti dresses her in purple, a colour that he associates with inactivity or even death. He quite possibly has a personal agenda here, as Lizzie, the model, was ill at this time. The money Ruskin paid for the painting enabled her to go for a cure in the south of France.

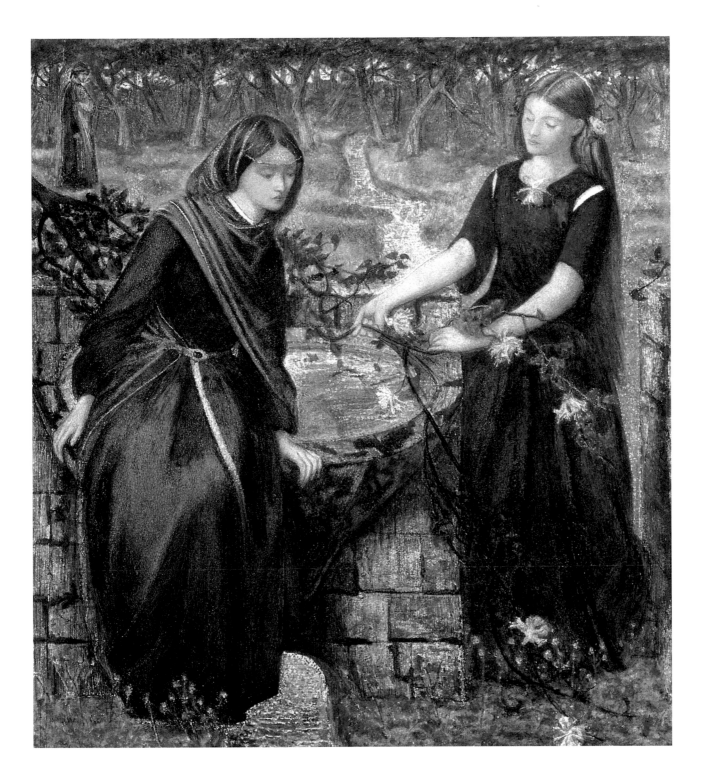

DANTE GABRIEL ROSSETTI
Beata Beatrix c.1864–70
Tate Gallery

This 'poetic work', as Rossetti called it, is very different from the 'fleshly' studies of his mistress Fanny Cornforth, which he was painting at the time. It is highly autobiographical, in effect a memorial to his dead wife, Elizabeth Siddal, who had committed suicide from an overdose of laudanum in February 1862. It is probably based on one of the many drawings he made of her before her death.

The artist himself described the painting after he had finally completed it in 1870. 'The picture must of course be viewed not as a representation of the incident of the death of Beatrice, but as an ideal of the subject, symbolised by a trance or sudden spiritual transfiguration. Beatrice is rapt visibly into Heaven, seeing as it were through her shut lids (as Dante says at the close of the *Vita Nuova* [poems]) "Him who is Blessed throughout all ages"; and in sign of the supreme change, the radiant bird, a messenger of death, drops the white poppy between her open hands. In the background is the City which, as Dante says "sat solitary" in mourning for her death; and through whose street Dante himself is seen to pass gazing towards the figure of Love opposite, in whose hand the waning of life of his lady flickers as a flame. On the sundial at her side the shadow falls on the hour of nine, which number Dante connects mystically in many ways with her and her death.'

But there is evidence that Rossetti is also making connections with Lizzie's death. He paints a white poppy held by a bird because she had died of an overdose of laudanum. The colours may also have a symbolic aspect; she wears a green tunic over a dress of purplish-grey, 'the colours of hope and sorrow as well as of life and death'. Could it be that Rossetti, despite his agnosticism, hopes desperately for an afterlife for his wife? The title *Beata Beatrix* implies that he would like her to find happiness in another place, perhaps an afterlife. In a sad, introspective poem, 'At Last', written after her daughter was still-born and not long before her suicide, Lizzie expresses a longing to leave the troubles of her earthly existence behind ('Tell him I died of my great love / And my dying heart was gay').

The soft focus around Lizzie's head, which gives the impression of a halo, may have derived from the deliberately soft-focus photographs of the Victorian photographer Julia Margaret Cameron. At the bottom of the painting is the line from the Old Testament book Lamentations 1:1, quoted by Dante in the *Vita Nuova* on the death of Beatrice: 'Quomodo sedet sola Civitas!' ('How doth the city sit solitary.') At the top is the date of Beatrice's death, 'Jun: Die 9; Anno 1290'. And nine o'clock was also the last time Rossetti, who was interested in number symbolism, saw Lizzie alive before he set out on the evening of her suicide with his friend Algernon Charles Swinburne. In the roundels are representations of the sun, the stars, the moon and the earth, referring to the last lines of Dante's *Divine Comedy*: 'Love which moves the sun and the other stars'.

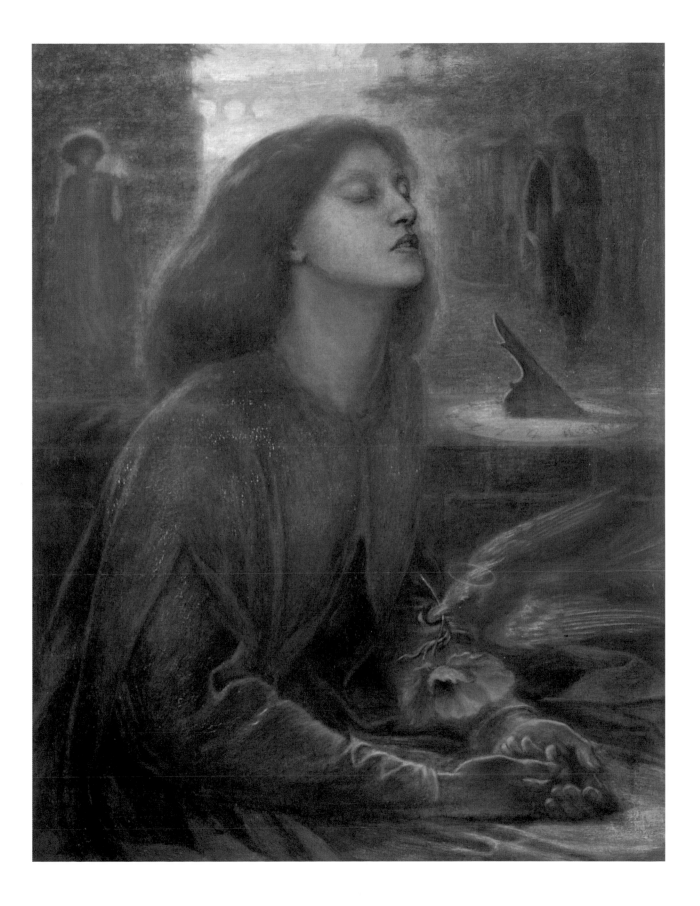

DANTE GABRIEL ROSSETTI
Proserpine 1873–7
Tate Gallery

The sensuous raven-haired beauty, Jane Morris, with whom Rossetti had begun a love affair in 1869, was the model for this subject. Until his death ten years later the artist never tired of painting or drawing her, just as he had obsessively painted Elizabeth Siddal in the 1850s.

The artist himself described the subject: 'The figure represents Proserpine as Empress of Hades. After she was conveyed by Pluto to his realm, and became his bride, her mother Ceres importuned Jupiter for her return to earth, and he was prevailed on to consent to this, provided only she had not partaken of any of the fruits of Hades. It was found, however, that she had eaten one grain of a pomegranate, and this enchained her to her new empire and destiny. She is represented in a gloomy corridor of her palace with the fatal fruit in her hand. As she passes, a gleam strikes on the wall behind her from some inlet suddenly opened, and admitting for a moment the light of the upper world; and she glances furtively towards it, immersed in thought. The incense burner stands beside her as the attribute of a goddess. The ivy branch in the background (a decorative appendage to the sonnet described on the label) may be taken as a symbol of clinging memory. The whole tone of the picture is a gradation of greys – from the watery blue-grey of the dress to the dim hue of the marble, all aiding the "Tartarean grey" which must be the sentiment of the subject.'

As in all Rossetti's paintings of Jane Morris, he has especially emphasised her large, expressive brown eyes and very full, sensual mouth. For Rossetti the eyes represented the spiritual being and the mouth the sensual aspect. The bitten pomegranate echoes the shape and colour of the red lips and also contains the seed. The ivy, often used in Pre-Raphaelite paintings, is a 'symbol of clinging memory' and also a 'decorative appendage'. The picture retains its original frame of wide, gold, bevelled boards decorated with roundels, resembling a section through a pomegranate. At the bottom, the sonnet was inscribed:

Afar from mine own self I seem, and wing
Strange ways in thought, and listen for a sign:
And still some heart unto some soul doth pine,
(Whose sounds mine inner sense is fain to bring,
Continually together murmuring,)–
'Woe's me for thee, unhappy Proserpine'.

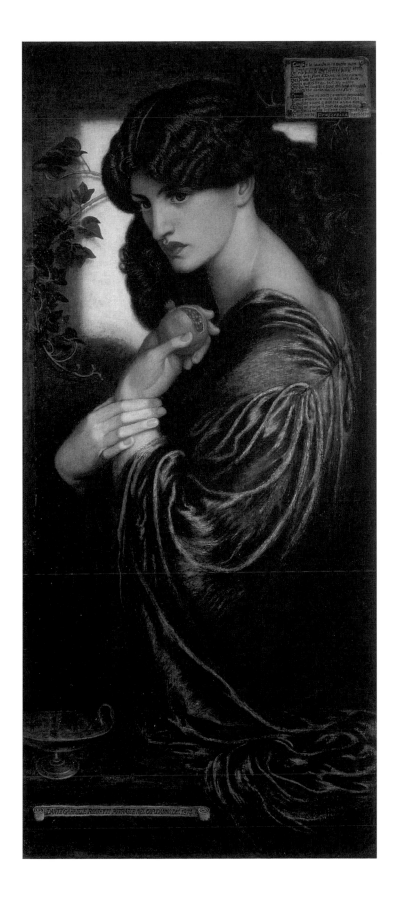

John Everett Millais
1829–1896

right
Photograph of Millais by Herbert
Watkins
National Portrait Gallery

left
JOHN EVERETT MILLAIS
The Order of Release, 1746, detail
(see p.65)

MILLAIS was a child prodigy, born in Southampton into a middle-class family from Jersey. His parents recognised their offspring's exceptional gifts and came to London in 1838 to secure the best possible art education. He entered the Royal Academy Schools at the age of eleven and went on to win a number of medals there.

Yet, despite his effortless mastery of everything he was taught and the Academy's approval of him, Millais, though always ambitious, clearly lacked a sense of direction, which perhaps explains the alacrity with which he seized upon the Pre-Raphaelite cause after his meeting with Hunt and Rossetti around 1848. The derivative nature of his painting *Cymon and Iphigenia* in 1848 suggests that, despite his amazing natural

facility, he needed intellectual focus and inspiration from others in order to fulfil his talent.

The brilliant, hard-edged virtuosity of his early Pre-Raphaelite paintings was crucial in formulating the early style of the Brotherhood, both in terms of technique and subject matter. His drawings from this early period further demonstrate his power and acumen as a draughtsman. He quickly followed his early masterpiece, *Isabella* (p.19), with *Christ in the House of his Parents* (p.61). He was by now developing his ability to paint with an almost obsessive attention to detail, as if everything in the painting was being examined under a microscope. In addition, he started to use symbols to enhance the meaning of each subject, a tradition in art which had been passed down from Hogarth in the previous century.

Christ in the House of his Parents caused huge controversy when first exhibited in 1850, at least in part because of its Roman Catholic undertones, which were deeply suspicious to an Anglican Victorian audience. Here in full is one of the least favourable critiques, written by Charles Dickens in his journal *Household Words*, which demonstrates the violence of the critical attack on the Brotherhood's early work:

You come into the Royal Academy exhibition, to the contemplation of a Holy family. You will have the goodness to discharge from your minds all Post Raphael ideas, all religious aspirations, all elevating thoughts, all tender, awful, sorrowful, ennobling, sacred, graceful or beautiful associations, and to prepare yourselves, as befits such a subject – a-Pre-Raphaelly considered – for the lowest depths of what is mean, odious, repulsive and revolting.

You behold the interior of a carpenter's shop. In the foreground of that carpenter's shop is a hideous, wry-necked, blubbering, red-headed boy in a bed-gown who appears to have received a poke in the hand from the stick of another boy with whom he has been playing in an adjacent gutter and to be holding it up for the contemplation of a kneeling woman, so horrible in her ugliness that (supposing it were possible for any creature to exist for a moment with that dislocated throat) she would stand out from the rest of the company as a monster in the vilest cabaret in France or the vilest gin-shop in England.

Clearly by now the critics were aware of the meaning of the initials P.R.B. inscribed on the paintings. But why did such technically brilliant works so enrage the critics? It is important to remember that these now familiar and well-loved images were initially planned as revolutionary paintings, to question accepted values and traditions in art. In an age of

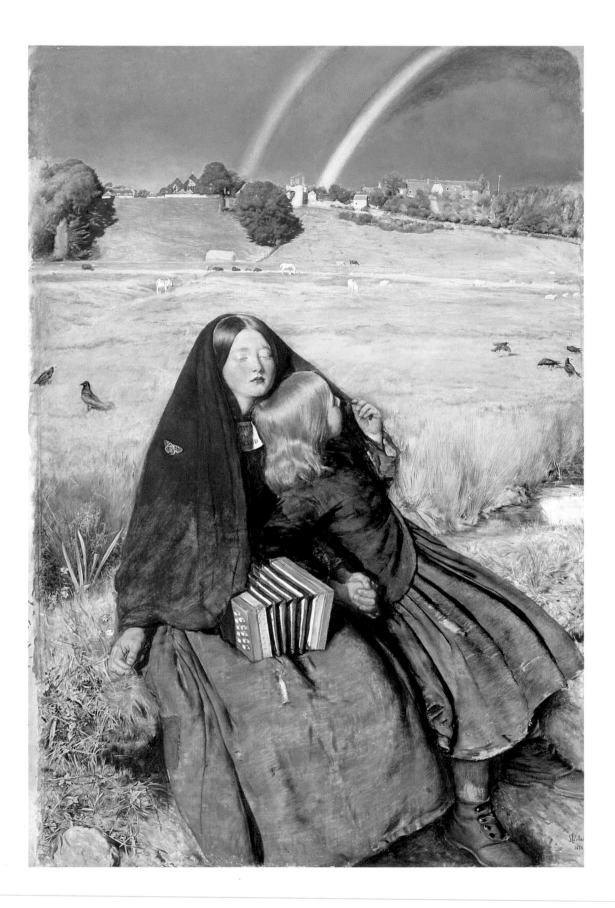

Although the background shows Winchelsea in Sussex, Millais painted some of the wild flowers and grasses at Perth (where he settled in 1855 after his marriage) and also used two local girls to model for this painting which was made at the height of his powers. The blind girl's lack of awareness of the beauty of the landscape is especially poignant, and the vibrant colour contrasts are characteristic of Millais in his early, hard-edged Pre-Raphaelite manner.

intense conservatism, the only reaction to such insolent and arrogant free thinking was outrage.

But this critical hyperbole and invective was only a minor set-back for Millais, the golden boy, who was embarking on one of the most successful careers in the history of English painting. By the age of twenty-four, after exhibiting the *The Order of Release, 1746* (1852–3; p.65), he had become one of the most popular and successful painters in England. He was also, ultimately, one of the wealthiest. Millais was deeply sensitive by nature, and the unprecedented viciousness of these early attacks did not go unfelt. But already he was attracting defenders of his work in high places. Queen Victoria's husband Prince Albert sprang to his defence, criticising in particular 'the vanity of professional writers on art who often strive to impress the public with a great idea of their own artistic knowledge'. Yet this could have a dreadful effect on the painters themselves, he insisted. 'An unkind word of criticism passes like a cold blast over their tender shoots and shrinks them up', he wrote.

But Millais was not one to 'shrink', at least not permanently. He had acquired another able champion in the art critic John Ruskin, who in a letter to *The Times* in May 1851 concluded:

And now I wish them all, heartily good speed believing in sincerity, that if they temper the courage and energy which they have shown in the adoption

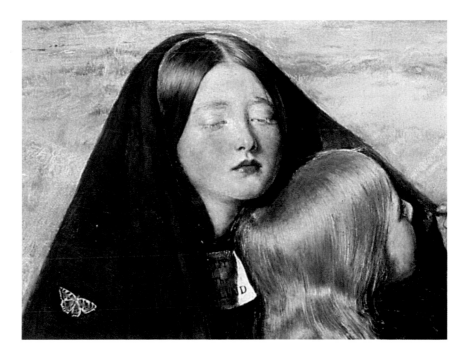

of their system with patience and discretion in framing it, and if they do not suffer themselves to be driven by harsh or careless criticism into rejection of the ordinary means of obtaining influence over the minds of others, they may as they gain experience, lay in our England the foundations of a School of Art nobler than the world has seen for three hundred years.

After a tactful interval, 'to make sure we should not be influencing in any degree or manner the judgement of the writer, Millais and I posted a joint letter to thank him for his championship', wrote Hunt. Clearly the Ruskins were won over by Millais's charm and winning ways as 'the next day John Ruskin and his wife drove to Millais's house. They saw my friend and after a mutually appreciative interview carried him off to their home in Camberwell and induced him to stay with them for a week', as Hunt describes it. This was followed by an invitation to go on holiday with the Ruskins in Glenfinlas in Scotland in the summer of 1853, during which time Millais was to paint a portrait of Ruskin posed in a mountainous setting. A little before this, Millais had asked Effie Ruskin to sit for his painting *The Order of Release, 1746* (p.65), set in Scotland in 1745. He clearly saw Effie's Scottish heritage as an appropriate reason for her to sit for the head of the Jacobite heroine who has secured her husband's release from jail.

The likeness turned out to be a good one and the first of many which Millais would make of Effie, for during the fateful Glenfinlas holiday the two of them fell in love. Millais had become increasingly aware of Effie's barren, loveless, and as it transpired, unconsummated marriage to the critic. He was outraged by Ruskin's mental cruelty. 'Why he ever had the audacity of marrying with no better intentions is a mystery to me,' he wrote. Finally and painfully, the Ruskins separated and their marriage was annulled on the grounds of non-consummation, a dreadful scandal at the time from which Ruskin never completely recovered. Millais and Effie married in July 1853 at her parents' home in Perth. It was a long and happy marriage which resulted in eight children. Not only Effie but also numerous relatives and acquaintances sat for many of Millais's early Pre-Raphaelite masterpieces such as *The Blind Girl* (1854–6; p.56) and the poetic, Tennysonian *Autumn Leaves* (1855–6), painted in Scotland with Effie's sisters Sophie and Alice, and two other local girls as models.

Yet, by the end of the decade, this brilliant early phase of Millais's hard-edged style had begun to decline. Arguably the need to feed a rapidly growing family made it less desirable to work for the several months

JOHN EVERETT MILLAIS
The Vale of Rest 1858–9
Tate Gallery

The melancholy theme, focusing on the transience of life, is reflected in the landscape. By this time Millais's observation of nature was gradually becoming less precise than in the early Pre-Raphaelite years.

which the precise, detailed execution of each canvas required. Possibly he was keen to develop stylistically from this youthful period. *The Vale of Rest* (1858–9; above) and *Sir Isumbras at the Ford* demonstrate a softening at the edges, a loosening of his previous, tightly executed, immaculate technique.

Although his later art is now less critically acclaimed, in particular the overt sentimentality of *The Black Brunswicker* (1859–60), *My First Sermon* (1863) or *Bubbles* (1886), Millais's career was one of virtually unbroken success. His society portraits, and particularly his late atmospheric landscapes, were admired for their brilliant technique, which, whilst rejecting Ruskin's values of detail and didacticism, established a new virtuosity. Millais was elected an Associate of the Royal Academy as early as 1853. In 1885 he was created a baronet and in his final years was reputed to have an income of £30,000 a year. In 1896 his supremacy was acknowledged by his election to succeed Frederic Leighton as President of the Royal Academy. The wheel had come full circle. The rebel art student who had reviled the first president, Sir Joshua Reynolds, had himself become part of the establishment. Sadly, it was an honour he had only a few months left to enjoy.

JOHN EVERETT MILLAIS

Christ in the House of his Parents ('The Carpenter's Shop') 1849–50

Tate Gallery

The subject of Joseph's carpenter's shop was not new in art, but Millais's highly realistic, almost documentary approach made it deeply controversial in its day. The picture became so famous whilst still on show at the Royal Academy in 1850 that Queen Victoria had it removed so that she might see it.

It is an early and ingenious example of Millais's meticulous symbolism. It was executed *in situ* in a carpenter's shop, where the painter slept in order to be ready for work early the next morning. Various members of his family sat for the picture, including his father who modelled for Joseph, and his brother William, who sat for his assistant. The sheep in the background were all painted from two heads bought from a local butcher. In the centre of the picture the Virgin Mary comforts the Christ Child, who has cut himself on a nail. In the background his cousin John the Baptist approaches with a bowl of water, symbolic of the baptism, whilst a dove hovers on a ladder above. The carpenter's shop, with wood, nails and tools, is in itself an analogy for the making of the cross. But a plethora of other symbols reinforce the subject of the Passion. The Christ Child's cut on his hand and the blood dripping onto his foot presages the marks made by the nails. The half-woven basket in the left-hand corner suggests the as yet uncompleted life of Christ, whilst the sticks are reminders of the Flagellation. The exotic red flower by the door is a symbol of the blood shed during the Passion and the sheep beyond are Christ's flock. On the opposite window ledge, birds drink from a bowl of water, a suggestion that followers of Christ are refreshed by Christianity. The triangular set square on the wall is a reminder of the Trinity.

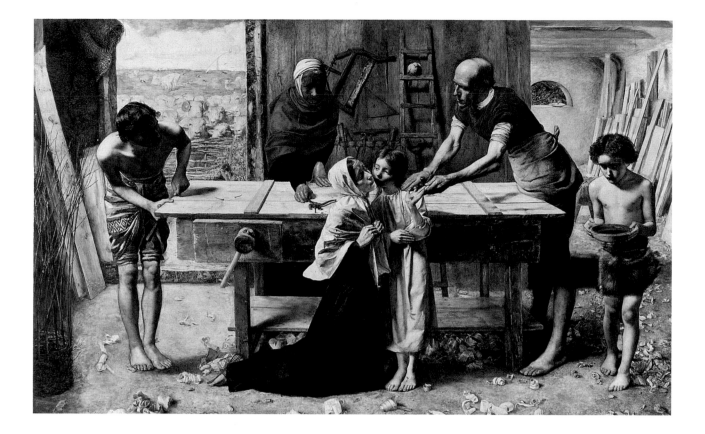

Ophelia 1851–2
Tate Gallery

The scene depicted comes from Act IV, Scene 7, of *Hamlet*, when Ophelia drowns in a stream, distraught with grief after Hamlet's cruel rejection of her and his subsequent murder of her father Polonius. The lure of Shakespeare and the tragic story of a beautiful heroine who dies in a natural setting had obvious appeal to the Pre-Raphaelites (Arthur Hughes painted another version at the same time). The painting, without doubt one of the artist's masterpieces, is executed with microscopic attention to every detail he perceived in nature. He went through his usual painstaking research to discover a suitable location 'of a small river with willows overhanging the banks', which he eventually found on the River Ewell in Surrey. Hamlet's mother, Gertrude, describes the scene in a beautiful, descriptive speech:

> There is a willow grows aslant a brook
> That shows his hoar leaves in the glassy stream;
> There with fantastic garlands did she come
> Of crow flowers, nettles, daisies and long purples…

The result of six months spent working *in situ* on the landscape, *Ophelia* is a dazzling, virtuoso display of Millais's extraordinarily acute talent for depicting the natural world, at the height of his powers in the early Pre-Raphaelite years. Every early summer flower, depicted with detailed botanical accuracy, carries at least one symbolic meaning. It is a painting rich in associations and inferences. The willow, the nettle growing amongst its branches and the daisies near Ophelia's hand are associated respectively with love, pain and innocence. The pansies, floating on the dress, can mean both thought – her sad thoughts were to lead to her death – or love in vain. The rose by her cheek symbolises love or could allude to her brother Laertes' description of her as the 'rose of May' in the previous scene.

Millais probably had more than one meaning in mind when he painted the chain of violets around her neck. Violets can mean death of the young, faithfulness or chastity, all meanings that might be appropriate for Ophelia. She also speaks of the violets that 'withered all when my father died' in the haunting 'mad scene' which precedes her suicide. Likewise, the robin in the upper left-hand corner probably refers to one of the snatches of songs she sings in her distracted way: 'For Bonny sweet Robin is all my joy.' The other flowers, such as the poppy, symbolising death, or the purple loosestrife, meaning uselessness, were Millais's additions rather than Shakespeare's. He has also added, close to the forget-me-nots in the right corner, a configuration of light and shade vaguely resembling a skull. This is a *memento mori* – a reminder perhaps not only of Ophelia's death, but of all the other deaths in *Hamlet*. It also anticipates Hamlet's graveyard scene with Yorick's skull in the final act.

Millais, who was always very thorough in trying to search out the right 'props' and costumes for his paintings, was delighted to find 'a really splendid lady's ancient dress – all flowered over in silver embroidery'. The story that Elizabeth Siddal posed in his studio in a bath full of water kept warm by oil lamps is one of the best known of all the Pre-Raphaelite tales. The illness she contracted as a result is often exaggerated. Her father did attempt

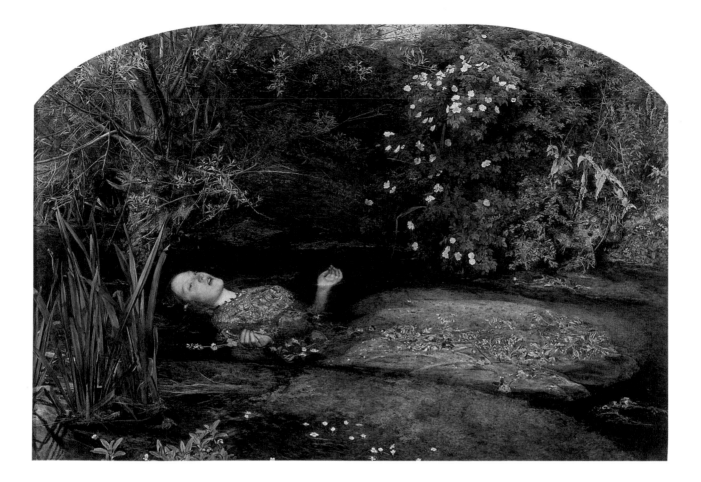

to sue Millais, who agreed in the end to pay the doctor's bill. He quite probably thought it was worth it – whether Lizzie did is less certain – determined as he was to depict every aspect of his picture with consistent attention to detail. He left behind an amusing account of the tedious procedures endured to complete the picture in one of his many detailed descriptions to his friend Hunt, who was undergoing similar vicissitudes at the time with his painting *The Hireling Shepherd* (p.17). Apart from revealing Millais's keen sense of the ridiculous, the letter provides an insight into the artist's extreme dedication in these early years:

I sit tailor fashion, under an umbrella throwing a shadow scarcely larger than a half penny for eleven hours, with a child's mug within reach to satisfy my thirst from the running stream beside me. I am threatened with a notice to appear before a magistrate for trespassing in a field and destroying the hay; likewise by the admission of a bull in the same field after the said hay be cut; am also in danger of being blown by the wind into the water and becoming intimate with the feelings of Ophelia when that Lady sank to muddy death, together with the (less likely) total disappearance, through the voracity of the flies. There are two swans who not a little add to my misery by persisting in watching me from the exact spot I wish to paint, occasionally destroying every water-weed within their reach… Certainly the painting of a picture under such circumstances would be a greater punishment to a murderer than hanging.

The Order of Release, 1746 1852–3

In this Scottish subject Millais's future wife Effie Ruskin sat for him for the first time. She described the painting as 'quite Jacobite and after my own heart'. The narrative, invented by Millais, is about a Jacobite rebel who has been imprisoned by the English after the defeat of Bonnie Prince Charlie's army at Culloden on 16 April 1746. His wife, who grasps their sleeping son, has secured his release, although how she has done so is not made clear. It is possible that she has had to sacrifice her virtue, which would give this painting links with Hunt's *The Awakening Conscience* (p.79).

Millais went about his usual careful researches to find the right background, trying firstly the Tower of London, then later Lambeth Palace. He had particular problems getting the baby and dog to pose: 'I have a headache and feel as tired as if I had walked twenty miles from the anxiety I have undergone this last fortnight,' he complained in a letter to his friend Thomas Combe. 'All the morning I have been drawing a dog which in unquietness is only to be surpassed by a child.'

This painting had a huge *succès d'estime* when it was first shown, at the Royal Academy; a policeman had to be installed in front of it to move spectators on. It was shown two years later at the Exposition Universelle in Paris where it was admired by both Gautier and Baudelaire.

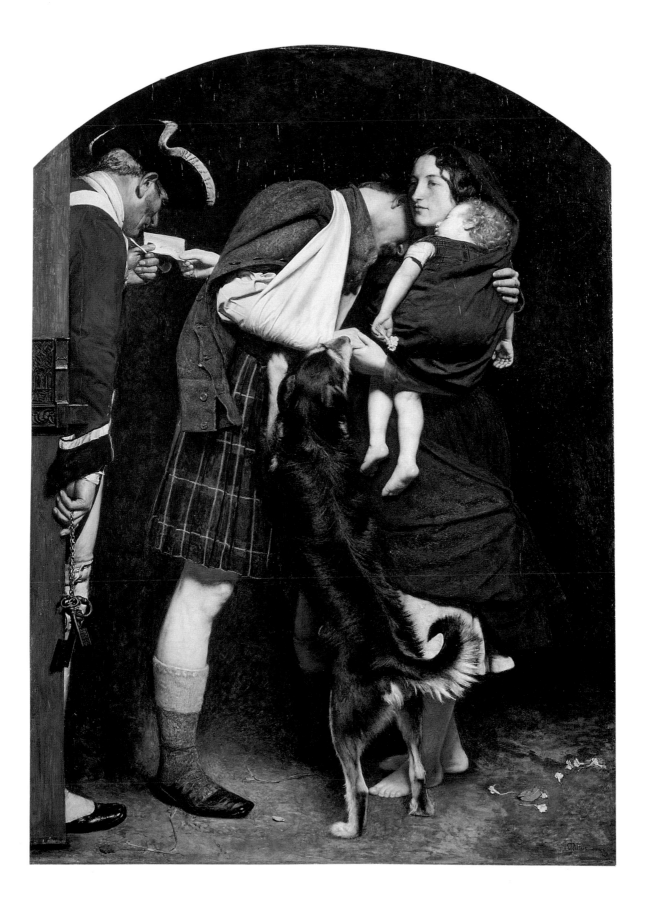

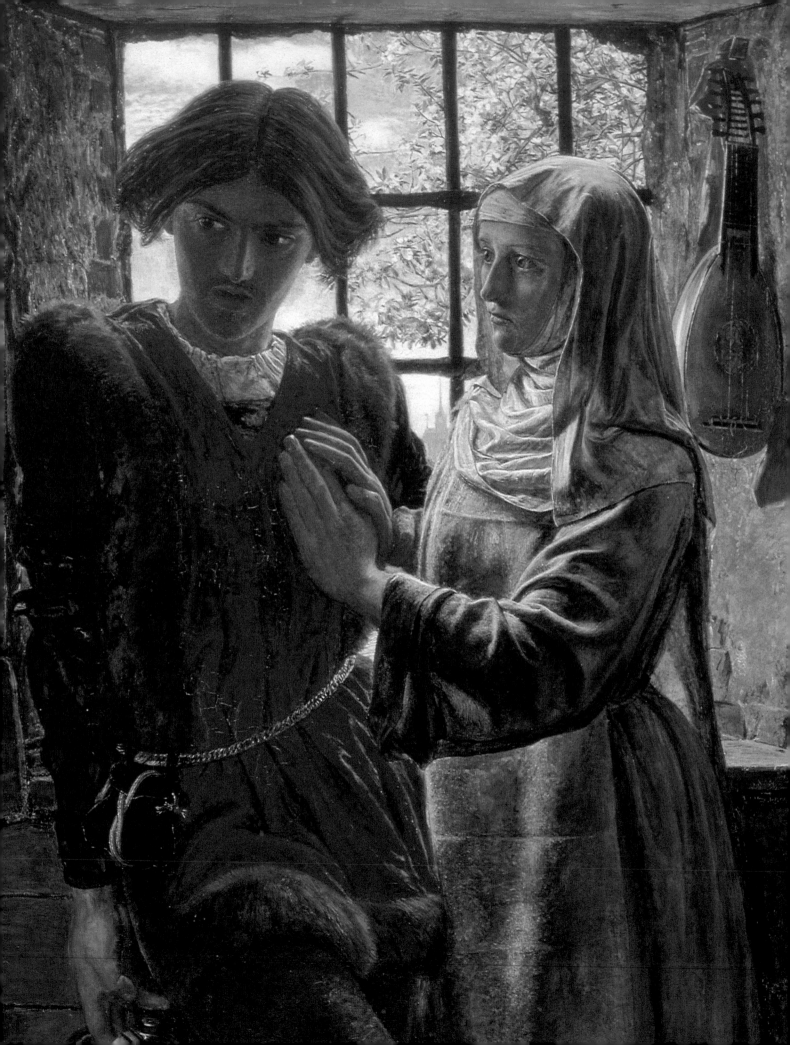

William Holman Hunt 1827–1910

right
Photograph of Hunt by David
Wilkie Wynfield, 1860s
National Portrait Gallery

left
WILLIAM HOLMAN HUNT
Claudio and Isabella, detail
(see p.75)

NICKNAMED the 'High Priest' of the movement because of his deep religious convictions, Hunt was the only artist of the original seven members of the Brotherhood to uphold the Pre-Raphaelite principles of moral seriousness and fidelity to nature in art to the very end of his career.

Unlike his fellow Brothers, Millais and Rossetti, Hunt did not have a family background which helped to nurture his artistic talent. His father, a warehouse manager in the City of London, strongly opposed his son's wish to become a painter, and he entered the Royal Academy Schools in 1844 against the wishes of his family. Hunt had worked as a clerk from the age of twelve and was a believer in the Victorian work ethic as a means

of improving his situation in life. He did not go to Sass's, the art school often attended before entering the Royal Academy, but he had done a variety of odd jobs and had studied independently. He supported himself, up to a point, by painting portraits.

His meeting with Rossetti and Millais at the Academy Schools was a turning point, and he embraced the Pre-Raphaelite cause with characteristic dedication. Together he and Millais formulated the hard-edged style and discussed the ideal of 'truth to nature' evident in early Pre-Raphaelitism. Hunt was also more responsible than the others for developing an art of symbolic realism in which every meticulously painted detail carries a meaning to elucidate further the subject of the picture. Hunt and Millais were very close in these early days. Millais, who was always a generous friend to the less privileged Hunt, confessed that he wept for days when Hunt set off for the Holy Land in 1853.

Hunt's Royal Academy picture *The Eve of St Agnes* (1848) played a crucial role in the initial formation of the Brotherhood. Although it was executed in a conventional style and technique, the fact that he had chosen a subject from Rossetti's hero, Keats, was of immediate interest to Rossetti the poet-painter. Although they would have known each other by sight, Rossetti and Hunt, who was by this time a friend of Millais, now became close friends, enthusiastically exchanging ideas. They already had artistic ideals in common; both had read Ruskin's *Modern Painters*. Later Hunt, who had a tendency to arrogance – possibly because of defensiveness about his lower-middle-class origins – and to take the credit for originating ideas, wrote in his autobiographical *Pre-Raphaelitism and the Pre-Raphaelite Brotherhood* (1905): 'My last designs and experiments I rejoiced to display before a man of his poetic instincts; and it was pleasant to hear him repeat my propositions and theories in his own richer phrase.' Hunt sold his *Eve of St Agnes* for £70 and with the proceeds rented a studio in Cleveland Street.

In his earliest Pre-Raphaelite works Hunt's earnestness and strongly religious nature are made apparent in themes which tackle issues of sexual hypocrisy, such as *The Awakening Conscience* (1853; p.79 and opposite) and *Claudio and Isabella* (1850; p.75). The latter subject was taken from Shakespeare's *Measure for Measure*, which to some extent reveals the orthodoxy and puritanism of Hunt's views on contemporary morality.

The Hireling Shepherd (1851–2; p.17), which was painted in Ewell in Surrey at the same time and place that Millais was painting his *Ophelia*

(p.62), is a prime example of early Pre-Raphaelite fidelity to nature. Its message is that the amorous dalliance of the shepherd has led to the escape of his flock into the corn. It also addresses the subject of sexual temptation, which could have had an autobiographical dimension for Hunt at this time. Both Hunt and Millais often provided a relevant quotation with their paintings and in this instance Hunt quotes from Shakespeare's *King Lear*: 'Sleepest or wakest thou, jolly shepherd? Thy sheep be in the corn.' But *The Hireling Shepherd* is a complex painting which operates on a number of other levels. One interpretation, reminiscent of *The Awakening Conscience* which Hunt would paint the following year, is that erotic feeling can take precedence over all else. Referring to the extraordinarily intense realism of this picture, Hunt later wrote: 'My first object was to paint, not Dresden china bergers, but a real shepherd and a real shepherdess and a landscape in full sunlight with all the colour of the luscious summer.'

It was typical of Hunt's independent nature that, despite the potential dangers of war in the Crimea and the discouragement of the other Brothers, he planned a trip to the Middle East. At this time, after a shaky start, Pre-Raphaelitism was establishing itself more favourably in the minds of critics and public. 'Will you persist in going to the East?', Millais wrote to him more than once. The emotional scene when he finally saw Hunt to the station was later recorded by the latter: 'What a leave taking it was with him in my heart when the train started! Did other men have such a sacred friendship as that we have formed?' Millais gave Hunt a signet ring in token of their friendship which Hunt wore to the end of his life.

There is little doubt that Hunt's desire to see the Holy Land was prompted at least in part by his faith. But he was also excited at the prospect of seeing and recording more exotic landscape. With improvement in travel it was becoming fashionable for painters and writers to venture further afield than the confines of Europe, and a number of contemporary Victorian painters, amongst them his friends Edward Lear and Richard Dadd, had made the same journey. Travelling via Paris, Marseilles and Malta, Hunt finally arrived in Cairo in the February of 1854. He was unimpressed by the Pyramids which he described as 'extremely ugly blocks'. 'Their only association which I value is that Joseph, Moses and Jesus must have looked at them,' he wrote.

The focus on Christianity, perhaps unsurprisingly, dominated the work he produced during his travels. *The Scapegoat* (1854–8; opposite), the best-

WILLIAM HOLMAN HUNT
The Scapegoat 1854–8
Manchester City Art Galleries

Hunt painted this on his trip to the Holy Land, where he had become fascinated with the challenge of painting landscapes very different to those he had painted previously in England. The figure of the abandoned goat is invested with much complex symbolism connecting Judaism and Christianity.

known painting of this trip and an archetypal Pre-Raphaelite image, was painted *in situ* at 'Oosdoom' on the Dead Sea. It was, according to Hunt, 'full of meaning'. His biblical source was Leviticus 16, which describes the ritual on the Jewish Day of Atonement when two goats are selected as symbols of the Jews' annual expiation of their sins. One should be sacrificed at the Temple and the other 'shall be presented alive before the Lord, to make an atonement with him, and to let him go for a scapegoat into the wilderness… and the goat shall bear upon him all their iniquities unto a land not inhabited'.

Hunt's intention was to make his *Scapegoat* into an analogy with Christ. The most spectacular aspect of the painting is the dramatic landscape. 'The mountains beyond the sea… under the light of the evening sun shone in a livery of crimson and gold,' wrote one of Hunt's travelling companions, the Revd William Beaumont. 'And then, as if to complete the magnificence of the scene, a lofty and most perfect rainbow spanned the

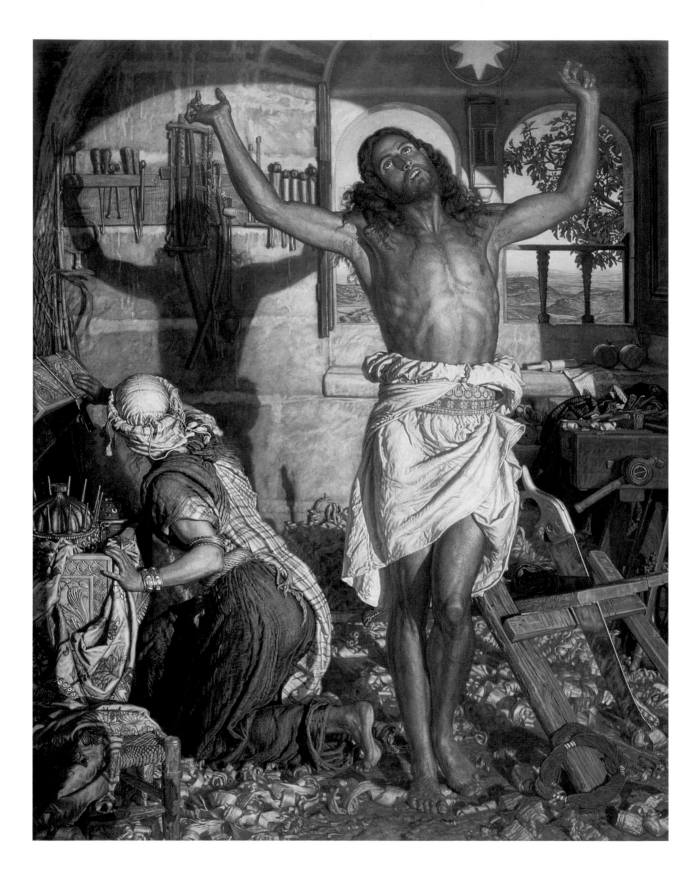

wide, but desolate space.' The painting received a mixed reception when finally seen in England. 'A grand thing, but not for the public' was Rossetti's comment.

Rossetti and Hunt's friendship had been somewhat tested during Hunt's trip to the Holy Land. Hunt had asked Rossetti to keep an eye on his girlfriend, the beautiful, uneducated woman from a Chelsea slum, Annie Miller, who posed for *The Awakening Conscience*. Rossetti, whose reputation with women went before him, did this rather too well, starting a flirtation with Annie, much to the consternation of both his wife Lizzie Siddal and, on his return, Hunt. Hunt ultimately decided against marrying Annie Miller (whom he had met when she was only fifteen) although their relationship continued for a while after his return. She modelled for a picture entitled *Il Dolce far Niente* or *Sweet Idleness*, which revealed much about Hunt's ultimate objection to Annie and, despite her considerable charms, her 'fatal indolence'.

He did not marry until much later, but his wife Fanny Waugh died in 1866, shortly after their marriage, after giving birth to their son. She was the model for Hunt's version of *Isabella and the Pot of Basil* (1866–8). Completed after her death, the painting became for Hunt both a celebration of his love for Fanny during their year of marriage and also an expression of his own deep bereavement.

Almost ten years later, Hunt married Fanny's sister Edith which was illegal in Britain under the deceased wife's sister Act. This may have been one of the reasons for Hunt's later avoidance of the Royal Academy and the art establishment in general. He exhibited for the last time at the Royal Academy in 1874, shortly after his marriage, and afterwards preferred to show through dealers.

Hunt's later works such as *The Shadow of Death* (1870–73; opposite) or *The Lady of Shalott* (1889) do not deviate in any way from the Brotherhood's original aims of realism. All the obsessive attention to detail persists, but often in a way that tends to over-elaboration, which can result almost in a sense of claustrophobia. It is arguable that both Hunt and Millais painted their best work during the 1850s, when the original Pre-Raphaelite ideas were still fresh and challenging.

Claudio and Isabella 1850

When the Brotherhood first formed in August 1848, Hunt and Rossetti had put Shakespeare high up on the list of Immortals (see p.13). Hunt had a particular interest in him, believing that the plays could be interpreted on a number of levels. Here he chooses a quotation from *Measure for Measure* Act III, Scene 1. Claudio, facing the death penalty for making his girlfriend Juliet pregnant, says to his sister Isabella, 'Death is a fearful thing.' His sister, who has been asked to abandon her nun's vows and become the mistress of the corrupt Angelo, replies: 'And shamed life a hateful.' By bathing Isabella in sunlight and clothing her in a simple white habit to symbolise purity, Hunt directs the viewer's sympathies towards the object of Angelo's lust. As in *The Awakening Conscience* (p.79), which he would paint in 1853, the subject is sexual hypocrisy, with the woman portrayed as a victim of men's selfishness and lust. A crisis between good and evil is also suggested.

Hunt has thought very carefully about the extremely claustrophobic composition, as a preliminary sketch confirms. Claudio, whose contorted pose was modelled by the handsome Walter Deverell, turns away from the window. The apple blossom, symbolising life, emphasises the troubled state of his mind. The blossom petals on the floor might also be seen as a symbol of Claudio's willingness to sacrifice his sister's virginity to save his life. Much is also made of Isabella's hands, placed over her brother's heart, as his life now lies, quite literally, in her hands. The pose reminds the viewer that it is Claudio's heart which has led him to his current predicament.

The lute in the window of the cell, painted during Hunt's visits to the Lollard Prison at Lambeth Palace, symbolises lust – both Claudio's and Angelo's – a reference taken from *Richard III*: 'To caper nimbly in a lady's chamber / To the lascivious pleasing of a lute.' The scarlet ribbons on the lute and Claudio's crimson jerkin are also emblems of passion.

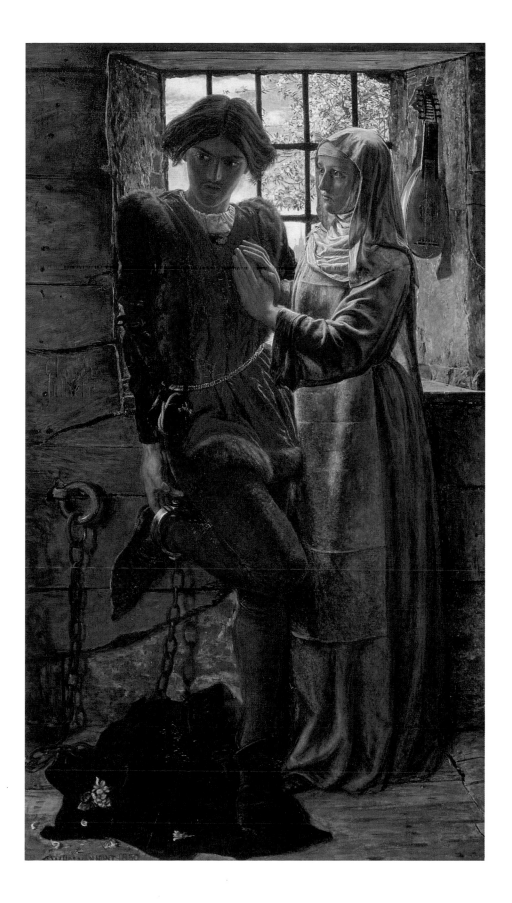

Our English Coasts, 1852 (Strayed Sheep) 1852

Tate Gallery

The brilliant luminosity of this sparkling landscape, executed out of doors on the Kent coast between Hastings and Fairlight, has made it one of the most famous Pre-Raphaelite landscapes. Hunt's astonishingly acute observations of the natural world, in particular the sunlight, caused Ruskin to write: 'It showed to us, for the first time in the history of art, the absolute faithful balances of colour and shade by which actual sunshine might be transposed into a key which the harmonies possible with material pigments should yet produce the same impression upon the mind which were caused by the light itself.'

Hunt painted the scene on the cliffs overlooking Covehurst Bay at a spot called Lover's Nest, in the company of his great friend the writer and painter Edward Lear. The cliffs, sheep and parts of the foreground vegetation were all painted from different viewpoints in the open air, but the butterflies in the left foreground were painted indoors from a live specimen. The man who commissioned this picture from Hunt for £70, Charles Maud, had insisted on a sunlit landscape, which was to cause Hunt much trouble through the stormy weather of the summer and autumn of 1852.

After the painting was exhibited at the Royal Academy in 1853, F.G. Stephens came up with the explanation that the painting might be taken as 'a satire on the reported defenceless state of the country against foreign invasion'. This was a topical subject as fears of a French invasion had been generated by press reports on Napoleon III's regime. But when Hunt decided to change the title from *Our English Coasts* to *Strayed Sheep*, he, more characteristically, was suggesting a religious symbolism akin to *The Light of the World* (1851–3; p.11), which he had just finished. The straying flock could be taken in a wider sense to mean men as sinners or, in a more specifically Protestant and topical interpretation, squabbles over points of doctrine.

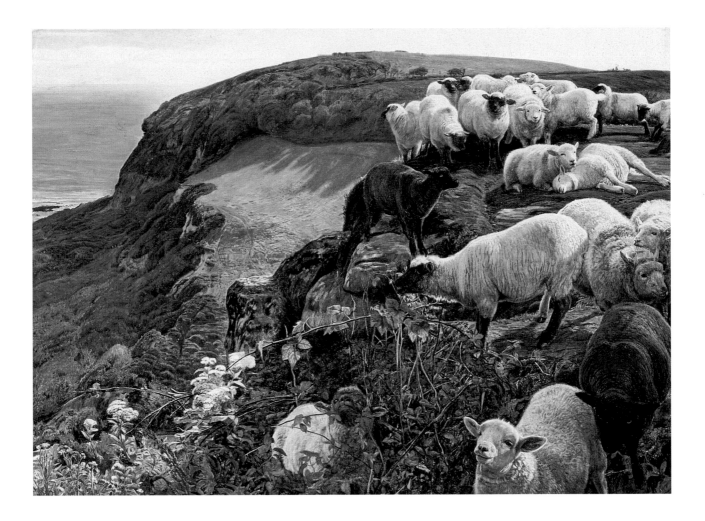

The Awakening Conscience 1853

The girl's radiant face is turned resolutely away from her lover. She looks outward, towards the window and the spectacle of nature beyond. For her this represents escape from her current predicament and the hope of a return to lost innocence. The ray of light which falls across the carpet in the foreground hints at the meaning which the painting's title makes plain. This is a moment of religious revelation. The girl's conscience, long dormant, has been stirred and she seeks an end to her past life. Her lover, perplexed, attempts to coax her back to his cosy embrace.

It is strange to reflect that, when this painting was first shown at the Royal Academy in 1854, visitors were both disturbed and shocked by the clear moral implications of the domestic drama. Hunt was painting a subject considered taboo within the narrow confines of Victorian society. Although the extent of prostitution in London was at the time notorious, any suggestion of it as a fit subject for a painting was totally unacceptable. One critic spoke of the girl's 'provocative state of undress'. Annie Miller, Hunt's beautiful girlfriend, was the model. He was at this time teaching her to read and the book on the table, which has been identified as *The Origin and Progress of the Art of Writing* (1853), is a reminder of this.

'As he that taketh away a garment in cold weather, so is he that singeth songs to an heavy heart', was the verse from Proverbs which initially inspired Hunt. He wanted, he said, 'to show how the still small voice speaks to the human soul in the turmoil of life'. The couple's unmarried status is immediately made clear by the absence of a wedding ring on the girl's hand. Her lover's top hat, deposited on the nearby table, suggests that he will not be staying long. This is not his home. The critic John Ruskin wrote in his review of the 'fatal newness of the furniture'. This is a set-up home for the man's mistress, and Hunt took care to find an appropriate room to use for the setting in St John's Wood, an area notorious for such arrangements.

Beneath the table the cat plays cruelly with his captive bird – a somewhat heavy-handed reminder of the man's cavalier treatment of the girl. Yet we see that the bird is also attempting an escape. The cast-off glove is a reminder of the common fate of prostitution for mistresses who are abandoned once their youth and beauty begin to fade. The web in which the girl finds herself trapped is symbolised both by the convulvulus in the vase on the piano and the tangled embroidery threads on the carpet. The sheet music on the floor is a tribute to Hunt's great friend, the artist and nonsense writer, Edward Lear, whose setting of Tennyson's 'Tears, idle tears' from the poem *The Princess* was published the previous year. The theme of past innocence clearly struck Hunt as appropriate. He hints further at the solution of chastity, by showing the figures of Chastity and Cupid on the clock on the piano.

Both Hunt and Millais were at this time interested in the idea of using additional symbols on the frame of the painting. Here Hunt designed marigolds as emblems of sorrow and bells of warning. The star at the top represents 'the still voice' of spiritual reawakening.

Ford Madox Brown
1821–1893

BORN in Calais in 1821, the son of a ship's purser, Ford Madox Brown, like Ruskin, was of an older generation than the members of the Brotherhood, which explains, at least in part, why he did not become a member himself. He was also temperamentally a loner, disinclined to become connected with any one movement. Yet Brown was a crucial influence on the younger artists and painted for a significant part of his career in the Pre-Raphaelite style, which he himself helped to formulate.

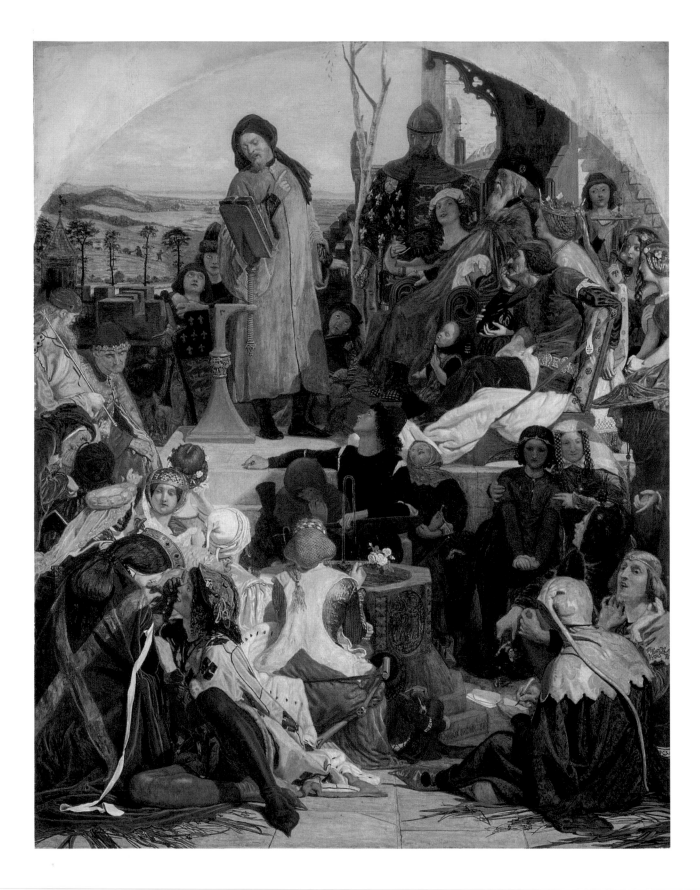

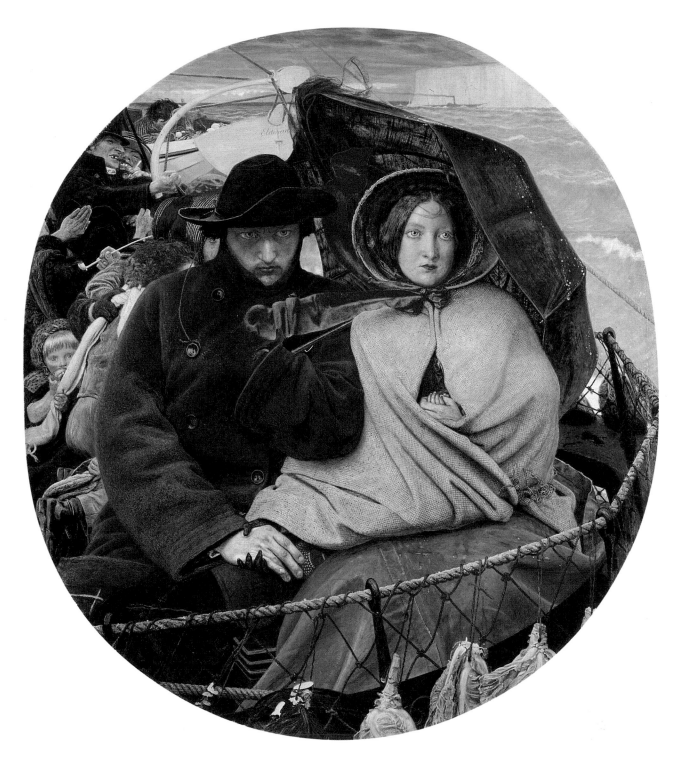

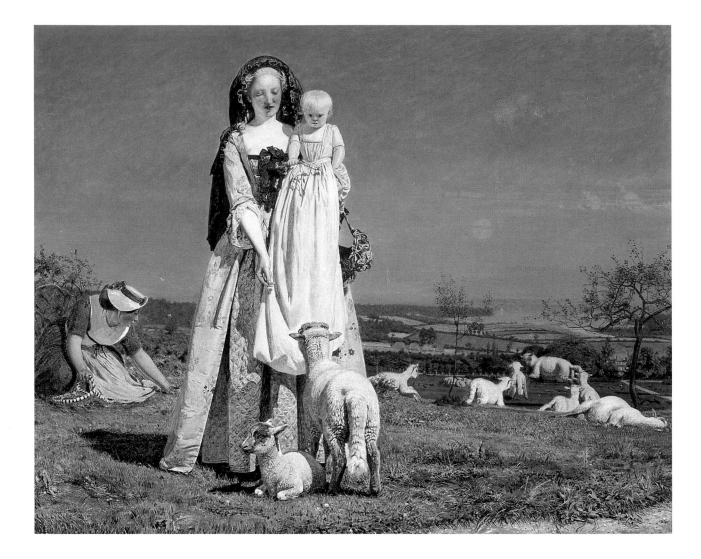

FORD MADOX BROWN
'The Pretty Baa Lambs' 1851–9
Birmingham Museums and Art Gallery

The deliberately sentimental title emphasises the freshness and innocence of this Pre-Raphaelite landscape, executed in direct sunlight.

As he lived most of his early life on the Continent, Brown avoided the usual training experienced by English art students. He studied first in Bruges and Ghent under Albert Gregorious, and then moved to the Antwerp Academy. Brown did not come to England until he was in his early twenties, in 1844, by which time he had married and had a baby daughter, Lucy, who was later to become an artist herself and to marry William Michael Rossetti. He continued to travel, and on a trip to Rome he made contact with the Nazarenes, a group of expatriate German artists led by Peter von Cornelius and Friedrich Overbeck. Their aims – to recapture the spirit of the Middle Ages and to make art serve a moral or religious purpose (their name came from their affectation of biblical dress) – had many affinities with the ideas of the as yet unformed Brotherhood. Two early works by Brown, *Chaucer at the Court of Edward III*

(1851–68; p.82) and *Wycliffe Reading his Translation of the Bible to John of Gaunt* (1847–61) both show Nazarene influence.

It was these two paintings which had a profound affect on the young Rossetti when he saw Brown working on them in his studio in 1847. Having discovered his work, he wrote him an extravagant letter of praise, asking him if he might become his pupil, as by now Rossetti was heavily disillusioned with what the Academy had to offer. Brown, touchy and oversensitive, thought the letter was mocking him, and went round to speak his mind to the young artist. But all was explained and an important artistic exchange began between the two men, one that would have considerable influence on the ideals and aims of the Brotherhood.

Brown's great forte was his treatment of the modern-life subject. *Work* (1852; p.14), painted in Heath Street, Hampstead, is one of the best known examples of this genre, speaking oceans, in its meticulously detailed way, of the Victorian work ethic and complex class structure. *'Take your son, Sir'* (?1851–92; p.87) confrontationally tackles the taboo subject of illegitimacy whilst *The Last of England* (1852–5; p.83) deals with the theme of emigration, which had reached a peak in 1852, the year Brown started on the picture. Thomas Woolner, who had decided to emigrate to Australia, was the initial inspiration, though Brown painted himself as the man. 'The husband broods bitterly over blighted hopes and severance from all he has been striving for,' Brown wrote of the painting. The woman who posed as his wife was Brown's favourite model, Emma, whom he married after the death of his first wife.

Suffering from a tendency to depression, Brown's early years were dogged by poverty and worries. 'Most of the time intensely miserable, very hard up and a little mad,' he latter recalled. But it was during this time, whilst living in south London, that he painted his masterly Pre-Raphaelite landscapes, executed painstakingly out of doors in bright sunlight. *'The Pretty Baa Lambs'* (1851–9; opposite), *Carrying Corn* (1854–5; p.37), *The Hayfield* (1855–6) and the later *Walton-on-the Naze* (1859–60) are all superb examples of Pre-Raphaelite fidelity to nature.

'Take your Son, Sir' ?1851–92
Tate Gallery

The meaning of this strange, unfinished painting has always been controversial. Brown's wife Emma and his new born baby son Arthur sat for the painting, and in the convex mirror in the background (inspired by van Eyck's *Arnolfini Marriage*) there is a man who looks very like Brown himself.

Perhaps because he has included all his own family, and because of the Madonna-like appearance of the woman, this painting has often been taken to be about the sanctity of marriage. But a very different interpretation is suggested by the title, which Brown did not give to it until almost ten years later. 'Take your Son, Sir' implies that the woman is in fact presenting the child's father with his bastard son and reminding him of his obligations. This meaning would put the painting far more within a social context and thus into the sphere of the modern-life subject, which was of such interest to the Pre-Raphaelites and to Brown, in particular. The interpretation is made more convincing by the contemporary heated debate over legal responsibility and custody of children. Lady Caroline Norton had raised the subject in her impassioned 'Letter to the Queen', published in *The Times*. In 1839 she had been instrumental in getting an amendment to the Custody of Infants Act.

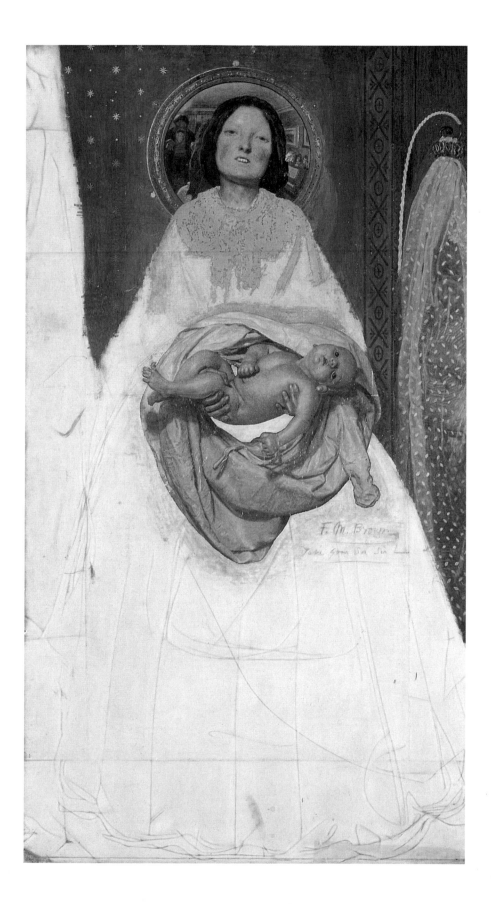

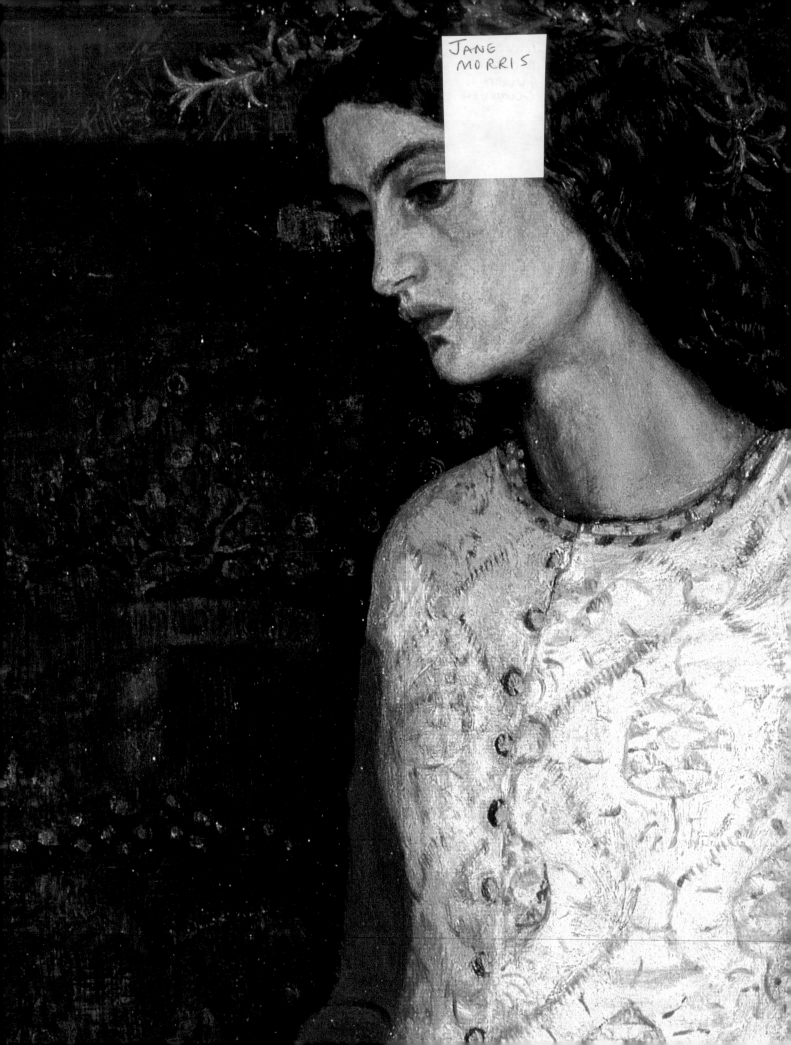

William Morris 1834–1896

right
Photograph of Morris, 1857
William Morris Gallery, Walthamstow

left
WILLIAM MORRIS
Queen Guinevere, detail (see p.95)

A HUNDRED years after his death, Willam Morris is remembered as one of the greatest English designers, but he had many other gifts and guises. He was also a poet, now ranked on a par with Tennyson and Browning, a philosopher and, in later years, a committed socialist and reformer. But he was never a natural painter. 'I cannot paint you, I can only love you', he wrote at the bottom of his strangely flat and unresolved painting of his beautiful wife, Jane Burden, who had posed for him as Queen Guinevere (opposite and p.95) in 1857, before their marriage. The adulterous love of King Arthur's Queen Guinevere for Sir Lancelot is one of the central themes of Malory's *Morte d'Arthur*, so this was a sadly prophetic choice of subject matter given Jane's later affair with

above
'Sussex' three-seat settle with rush seating, manufactured by Morris and Co. from *c.*1865.
William Morris Gallery, Walthamstow

Like Rossetti, Morris wished to return to ideas and styles which pre-dated the Renaissance.

left
Photograph of Jane Morris, 1858
Victoria & Albert Museum

This suggests that Rossetti did little to exaggerate the drama of Jane's good looks.

Rossetti. Morris's early poem, 'Praise of My Lady', better expressed his adoration for her.

> Her great eyes, standing far apart,
> Draw up some memory from her heart,
> And gaze out very mournfully,
> > *Beata mea Domina!*

> So beautiful and kind they are,
> But most times looking out afar,
> Waiting for something, not for me.
> > *Beata mea Domina!*

'Strawberry Thief', block-printed
cotton designed and printed by
William Morris (registered in 1883)
Victoria & Albert Museum

Morris's designs for textiles,
wallpaper, tapestry and carpets
exhibit the same concern for
naturalism as the Pre-Raphaelite
Brotherhood had demonstrated from
the first.

As a child, Morris was a dreamer, fantasising about medieval tales of
chivalry. When, aged seventeen, he went to the Great Exhibition of
1851, he was appalled at the lack of craftsmanship that he witnessed
there and he resolved to improve design in England.

At Oxford his importance as a poet and writer began to develop, and
he also met his life-long friend and working associate, Edward Burne-
Jones, who shared his passion for everything medieval. Ruskin, Tennyson
and the Pre-Raphaelites were their heroes. In August 1856 Morris and
Burne-Jones moved into rooms at No.1 Upper Gordon Square in Blooms-
bury, an area with which Morris was to have a long association. Not long
after moving there, Morris met the charismatic Rossetti for the first time,
and both he and Burne-Jones were captivated by Rossetti's considerable
charm, although a remark of Burne-Jones reveals that they were already
aware of his more dangerous side. 'Ah, Gabriel was the one to tell things
to,' he said. 'No, Gabriel on second thoughts was not the one to tell things
to – and second thoughts are best.'

But in those early days Rossetti was a crucial influence, and both Morris and Burne-Jones were swept along by his ideas and intense enthusiasms. Rossetti, who believed, or professed to believe, that anyone could be a painter, encouraged Morris to paint, but Morris was rather less confident, writing in the summer of 1856: 'Rossetti says I ought to paint, he says I shall be able; now as he is a very great man, and speaks with authority and not as the scribes, I must try. I don't hope much, I must say.'

Morris met the eighteen-year-old 'stunner', Jane Burden, after he and Rossetti had seen her at the theatre with her sister in Oxford in October 1857. Morris fell instantly in love with her exotic, rather foreign, dark good looks, idealising her for her beauty. 'Topsy [Morris's nickname] raves and swears like or more like any Oxford bargee about a "stunner" that he has seen,' wrote Crom Price, a fellow undergraduate. Morris married Janey two years later. In years to come she was to admit that she had never been in love with Morris, but coming from a working-class background, his offer of security and comfort was too good to miss; it was Rossetti, not Morris, whom she loved.

In 1859 Morris moved with his new wife into the Red House in Bexley, Kent, built by his friend Philip Webb. The experience of furnishing and decorating this house gave Morris and his friends the impetus to form Morris, Marshall, Faulkner and Co. in 1861. The other partners in the firm were Burne-Jones, Rossetti, Madox Brown and Philip Webb. 'The Firm', as it became known, was responsible for designing and painting interiors and for manufacturing high quality furniture, stained glass, tiles, tapestry, wall-paper, embroidered hangings and metal work. Morris's visual influences were widespread; he drew on rococo, Asian, Indian and Japanese art.

In 1874 the firm was reformed on a more business-like basis as Morris and Co. and Rossetti and Madox Brown dropped out. It was at this time that the firm began to produce a series of remarkable illuminated manuscripts. Later, in the 1890s, Morris founded the Kelmscott Press, to reintroduce the idea of the 'book beautiful', the edition of Chaucer becoming the most famous.

In later years Morris also emerged as a political activist, helping to found the Socialist League in 1884, but he became increasingly disillusioned with the feuding amongst the socialist leaders and gradually took a less militant part in the movement. He reserved his energies to play a leading role in the establishment of the Arts and Crafts movement, and also became involved with the Art Workers Guild.

Queen Guinevere 1858

Morris began work on this painting of his future wife, Jane Burden, in medieval dress, whilst Rossetti was teaching him to paint in 1858. It is possible that he was still working on it when the couple had moved to their new home, Red House, as the background may depict their bedroom there. The two men had 'discovered' the beautiful Janey, the daughter of an ostler, at the theatre one night whilst they were working at the Oxford Union on murals illustrating the *Morte d'Arthur*. Her stunning dark looks immediately made her a favourite Pre-Raphaelite model, supplanting even Lizzie Siddal herself, possibly also in Rossetti's affections. Later, after she had begun her long-lasting affair with Rossetti, she intimated that she had never been in love with Morris but that his moneyed background made him too good a proposition to refuse for a girl from her humble origins.

Morris's awkwardness as a painter is evident in this strangely flat portrait which he referred to as 'the brute'. Figure drawing and painting in general did not come easily to him, and quite quickly he would abandon it with relief to turn to design and the foundation of Morris and Co. Indeed the most interesting aspects of the portrait are the patterns on the dress, carpet, rug and bedspread. Janey's extraordinary beauty, evident in contemporary photographs, is not as celebrated here as it was to be in the many paintings and drawings Rossetti made of her after their affair had began. (Yet interestingly, much later, Rossetti asked if he could have *Queen Guinevere*, which Morris had given to Madox Brown's son Oliver). Janey's diffidence and introspection, which many described after meeting her, has been captured in the painting. Morris, the shy and awkward lover, was destined to be unrequited, which is expressed both in this work and his poems of the time.

Edward Coley
Burne-Jones
1833–1898

right
Photograph of Burne-Jones by Scott
and Scott, 1874
National Portrait Gallery

left
EDWARD BURNE-JONES
The Golden Stairs, detail
(see p.105)

ROSSETTI was the single greatest influence on the art of Edward Burne-Jones. Without his influence he would have been a very different artist and might not have become the most important member of the second generation of Pre-Raphaelites. His meeting with Rossetti in London early in 1856, in the company of his life-long friend William Morris, was a turning point in Burne-Jones's life. He was at this point studying at Exeter College, Oxford, with the intention of becoming a priest, but afterwards abandoned all thoughts of entering the Church. He had met Morris at Oxford and after studying Ruskin's writings together and looking at Pre-Raphaelite paintings they had resolved to devote their lives to art.

From the beginning of his career as a painter, Burne-Jones sought to escape the world of modern industrialism in favour of a romantic world of art and beauty. 'I mean by a picture', he wrote, 'a beautiful romantic dream of something that never was, never will be – in a light better than any light that ever shone – in a land no one can define or remember, only desire – and the forms divinely beautiful.' After their first meeting, Rossetti described Burne-Jones as 'one of the nicest young fellows in Dreamland'.

Burne-Jones had been forced to enter Dreamland early. He was born in Birmingham in 1833, and his mother had died six days after giving birth to her only child. His confused, grief-stricken father, who was by profession a carver and gilder, had felt unable to touch the little boy until he was four years old, and always unconsciously blamed him for his mother's death.

From earliest memory, the lonely child sought refuge in drawing, almost compulsively, a habit he retained until the end. Later he wrote: 'I was always drawing. Unmothered with a sad papa, without a sister or brother, always alone, I was never unhappy because I was always drawing.'

Burne-Jones's drawings, which show the artist's stylistic development through Aestheticism towards Symbolism, are often more tender and direct than his paintings which, at worst, can be overworked and repetitious. He only made portrait drawings when he felt that he had a particular rapport with a sitter and, like Rossetti, had a tendency to idealise and romanticise features. In his study for a female head (1865) for his painting *The Hours* (1882), his acute sensitivity to beauty and vulnerability is especially arresting.

By 1860 Burne-Jones was an active member of Morris and Co., contributing a big output of drawings and designs, in particular for stained glass. This same year he married Georgiana Macdonald, a woman whose strength provided a much needed balance to his highly strung temperament. It was an uncomplicated love and Georgiana's face was frequently his inspiration in early Rossetti-influenced works such as *The Golden Stairs* (1872–80; p.105). In his recently rediscovered *Belle et Blonde et Colorée*, a title suggested by his friend, the poet Swinburne, Burne-Jones probably used Georgie's 'tyrannously beautiful' sister Agnes (who later married the painter Edward Poynter) as the model. This work is related to an early masterpiece, the watercolour of the evil *femme fatale*, *Sidonia von Bork* (1860; p.103), often cited as a prototype of art nouveau.

During his trips to Italy in 1871 and 1873, Burne-Jones made a study

EDWARD BURNE-JONES
Fair Rosamund and Queen Eleanor
1862
Tate Gallery

Initially deeply influenced by
Rossetti, Burne-Jones went on to
create his own very personal
response to the aims of the
Brotherhood, as this early
work shows.

of the Renaissance painters, in particular Mantegna, Botticelli and
Michelangelo, whose influence became increasingly discernible in his
work, helping to create his mature style. This was finally acknowledged in
a wider context when he exhibited eight pictures at the opening exhibi-
tion of the Grosvenor Gallery, which brought him fame almost over night.

In the first half of the 1860s the British art press had celebrated what
they saw to be the end of Pre-Raphaelitism. In 1864 the *Art Journal*
declared: 'It is surprising, as it is satisfactory, to see how completely the
ultra and more repellent forms of the Pre-Raphaelite school have died
out. This slavish style has had its day.' This had an element of truth. Even
the Pre-Raphaelites themselves, with the notable exception of Hunt,
agreed that the phase of microscopic realism was over. Gradually a second
phase of the movement had developed. In place of the overriding con-
cern with nature and detailed symbolism, there was a new concern with
aesthetic ideals – Whistler's ideal of 'art for art's sake'. Sidney Colvin, a
friend of Burne-Jones and later Slade Professor at Cambridge, summed
up this new feeling in 1867 when he wrote: 'Beauty … should be the prime
objective of pictorial art. Having this it has the chief requisite.' Oscar

Wilde also perfectly expressed the new amorality of Aestheticism in his preface to *The Picture of Dorian Grey* (1891): 'There is no such thing as a moral or an immoral book. Books are well written or badly written. That is all.'

Burne-Jones was in the vanguard of the new Aesthetic movement. The controversy was expressed most forcibly in public when Whistler sued Ruskin for libel for his criticism of Whistler's *Nocturne in Black and Gold: The Falling Rocket* (1875). The case came to trial in 1878 and, perhaps surprisingly, Burne-Jones appeared for Ruskin. This seems to have been more on the grounds of friendship than a real identification with the critic's cause, however, as later he wrote: 'Do you remember when I let myself be put in a pillory to help him at Whistler's trial … and even thought him right and Whistler wrong in a way?'

Burne-Jones's passionate and destructive love affair with the Greek sculptress, Maria Zambaco, finds expression in a number of paintings. Her sharp features and soft, gentle eyes reappear obsessively, just as Lizzie Siddal and Jane Morris had in Rossetti's work. But Zambaco's and Burne-Jones's creative temperaments were too closely matched and the affair brought both lovers dangerously close to tragedy. When Maria suggested a mutual suicide pact, Burne-Jones tried desperately to end the affair. Whether he ever did remains a mystery. He was at his most distraught when he painted *Souls on the Banks of the River Styx* (c.1873), an untypically sinister painting which was clearly a *cri de coeur*.

In *Love and the Pilgrim* (1896–7) the pursuers Prince and Pilgrim are shown gazing in awe at Beauty enthroned. Now aged nearly sixty-four and far from well, Burne-Jones has here moved away from his earlier images of love. The perfect, other-worldly beauty of the woman no longer represents the individual features of Georgie or even Maria. It is a composite one, perhaps a combination of the qualities the artist had loved in different women. But her expression is evanescent, elusive. For Burne-Jones the mysteries of love and existence, from his motherless childhood to maturity and fame, remained unfathomable.

Burne-Jones often worked on his pictures over many years. As a result, there is exceptionally little stylistic development in his work. Medieval legends, classical myths and Bible stories were his main subjects. His later work was often on a much grander scale, often easel versions of designs he made for stained glass or tapestry. His reputation reached a height in England in 1890 when his *Briar Rose* paintings were shown at the art dealers Agnew's in London.

EDWARD BURNE-JONES
King Cophetua and the Beggar Maid
1884
Tate Gallery

Like Rossetti and other members of the Brotherhood, Burne-Jones delighted in using favourite models for his work. In this well-known painting he features his lover, the beautiful Greek sculptress Maria Zambaco, as the beggar maid, in a subject which demonstrates the power of love overcoming class barriers.

EDWARD BURNE-JONES
Sidonia von Bork 1860
Tate Gallery

This painting was inspired by Wilhelm Meinhold's romance, *Sidonia von Bork, die Klosterhexe*, first published in 1847. The story tells of a woman of noble Pomeranian family, who in 1620, at the age of eighty, was burnt as a witch at Stettin. She was so astonishingly beautiful that everyone who saw her fell instantly in love with her. But Sidonia was as evil as she was beautiful. She plotted with her lover, the leader of a gang of outlaws, bewitching the whole ruling house of Pomerania so as to cause their death or sterility. Here she is seen as a girl of twenty, plotting her next crime.

Both the subject and Burne-Jones's exquisite handling of it in watercolour, which he had began to favour at this time, demonstrate a second stage of Pre-Raphaelitism; a move away from medievalism and a new interest in Venetian art and stories of Renaissance crimes. The idea of the *femme fatale*, for which Rossetti said he had conceived 'a positive passion', was also of great interest to the Symbolists, with whom Burne-Jones was increasingly associated. The poet Swinburne, a close friend of both Rossetti and Burne-Jones, was also fascinated by this subject, and in particular by the combinations of beauty and evil, pain and eroticism, which Sidonia's story might be seen to reflect.

Burne-Jones's now famous image was later seen as a prototype of the ornamental style known as art nouveau. The painting's richly decorative appearance is enhanced by the background, reminiscent of the stained glass windows he was beginning to design for Morris and Co. at this time. The amazingly undulating design of Sidonia's dress was derived from Giulio Romano's Renaissance portrait of Isabella d'Este which the artist had been to see at Hampton Court near London.

The Golden Stairs 1872–80

The Victorian audience who first saw this painting when it was exhibited at the Grosvenor Gallery in 1880 were puzzled by the lack of narrative in the work, accustomed as they were to the concept that 'every picture tells a story'. The fact that the painting is ambiguous, poetically suggestive of mood, demonstrates the artist's sympathies with the Symbolist and Aesthetic interest in enigmatic works that have no one explanation. The French Symbolist poet, Stéphane Mallarmé, later summed this up: 'To name an object is to suppress three-quarters of the enjoyment to be gained from a poem … suggestion, that is the dream.'

This timeless procession of beautiful girls, many of them carrying musical instruments as they descend a golden staircase, has affinities with Whistler's interest in the analogy between art and music. Burne-Jones loved music and frequently attended concerts and the opera.

In this painting members of his family, including his daughters, sat for him. When he had finally finished the work, his wife, Georgiana, wrote: 'The picture is finished and so is the painter almost. He has never been so pushed for time in his life.'

Arthur Hughes 1832–1915

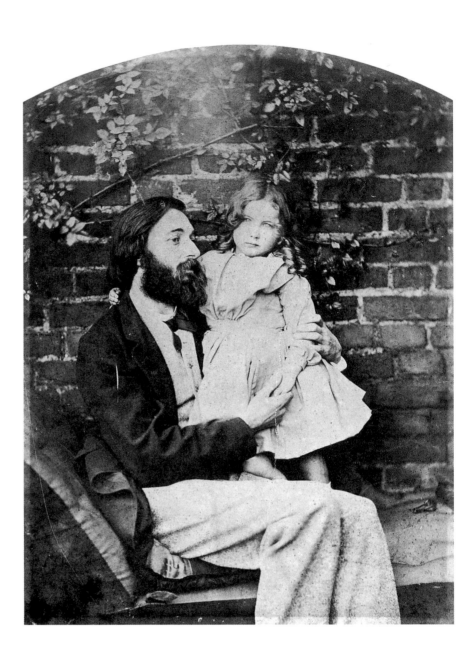

Photograph of Hughes with his daughter Alice, by Lewis Carroll

ARTHUR Hughes's painting *April Love* (1855–6; p.109) is one of the most famous of all Pre-Raphaelite images. It is also one of the most popular paintings in the Tate Gallery. Yet Arthur Hughes has never become as widely known as the members of the Brotherhood. Why is this? The technical brilliance and virtuosity of some of his work is certainly on a par with the best of Pre-Raphaelite painting.

Hughes was a gentle, modest man. His friends within the Brotherhood were unanimous in their good opinion of him. William Michael Rossetti, the chief chronicler and historian of the movement, wrote: 'If I had to pick out the sweetest and most ingenious of all my male friends, the least

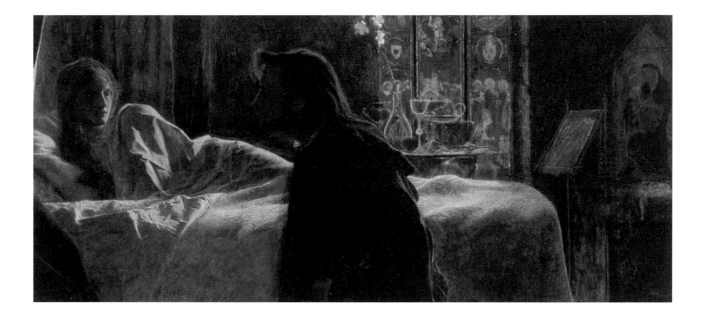

ARTHUR HUGHES
The Eve of St Agnes, detail
(see p.111)

carking and querulous and freest from envy and hatred and malice and all uncharitableness, I should probably find myself bound to select Mr Hughes.'

Unlike the much better known Millais, Rossetti and Hunt, Hughes enjoyed a quiet domestic family life lacking in drama. Although the Pre-Raphaelite Brotherhood was based, at least initially, on the enthusiasms of youthful friendships, as its members matured and developed, the inevitable jealousies, ready criticism and competitiveness were as prevalent as with any other group of creative, sensitive men. Yet Hughes, despite his consistent and perpetually disappointing lack of critical acclaim, remained generous and unembittered.

Although Hughes was not present at the first Pre-Raphaelite meeting in Millais's studio in Gower Street in the summer of 1848, he was a passionate follower of the Brotherhood's ideals. His reading of the first issue of the short-lived Pre-Raphaelite periodical *The Germ* in 1850 gave him immediate inspiration to change his style and learn to work in the Pre-Raphaelite manner. Hughes met the young Millais whilst they were students at the Royal Academy and became influenced by his interest in 'truth to nature'. He worked next to Millais so that he could observe at first hand the painstaking, laborious methods of Pre-Raphaelite technique. He was also drawn to the Brotherhood, as he shared their love of the Romantic poets, most especially John Keats, who was listed amongst the Immortals at the first Pre-Raphaelite meeting.

ARTHUR HUGHES
April Love 1855–6
Tate Gallery

April Love was the first painting Hughes embarked on to be inspired by a contemporary poet. He both read and admired Alfred Tennyson, who had been listed as one of the Immortals at the Gower Street meeting. Both Rossetti and Millais had already illustrated works by him. Hughes was inspired by a quotation from one of the songs in Tennyson's poem 'The Miller's Daughter', where the lovers are struck by the thought that their love may fade: 'Love that hath us in the net, Can he pass, and we forget?'

The landscape, executed with the meticulous attention to detail also seen in Millais's *Ophelia* (p.63), was painted in a friend's garden, in keeping with the Pre-Raphaelite preference for painting scenes from nature out of doors. The figures, however, were mostly painted in his studio and it is likely that Hughes's friend, the sculptor Alexander Munro, sat for the somewhat indistinct head of the lover in the background. The model for the girl is Hughes's fiancée Tryphena Foord. Initially, Hughes had used another model who had not approved of her likeness and left. The way the couple are backlit, whilst other parts of the painting are comparatively dark, is reminiscent of Hunt's *Claudio and Isabella* (p.75). Hughes employs the rose petals strewn on the floor in the same symbolic way as Hunt in his painting.

The painting's greatest strength is the vibrant contrasts of greens, lilacs and mauves. The fidelity to textures, both in the girl's costume and the foliage, sees Hughes at the peak of his Pre-Raphaelite observation of nature. There are some lovely passages in the painting: the light shining through the lilac and leaves just behind the girl is quite arresting. Hughes has used the landscape and his palette to intensify the emotion expressed. The way in which the young girl turns away in a seemingly abrupt and impulsive gesture with a tremulous expression expresses perfectly the fragility of young love which is the subject of 'The Miller's Daughter'.

The pencil and wash study for *April Love* at the Tate Gallery shows Hughes's initial uneasiness with the composition, particularly the way in which the girl and lover relate to one another. He changes the position of the lover's head in the original, although the girl's pose remains unaltered.

April Love was destined to remain in Pre-Raphaelite hands, as the man who finally bought the painting was the young William Morris.

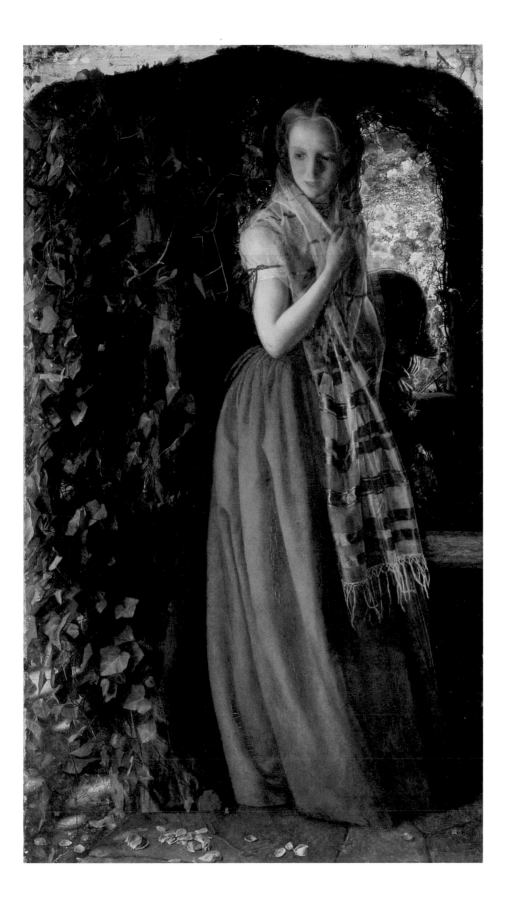

The Eve of St Agnes 1856
Tate Gallery

The next large-scale work Hughes embarked upon after *April Love* was *The Eve of St Agnes*, a Keatsian theme which he had admired when Hunt had tackled it in one of his earliest Pre-Raphaelite paintings. His interpretation of the poem is highly romantic and close in spirit to Keats's lines for which he clearly had a strong empathy.

The first panel on the left of the triptych shows Porphyro approaching the castle ('Meantime across the moors, had come young Porphyro, with heart on fire for Madeline'). Hughes has paid particular attention to Keats's phrase 'Buttress's from Moonlight', as a rather eerie, ghostly lighting dominates this panel.

The central panel shows Porphyro kneeling at Madeline's bedside. In capturing the mood of romantic young love Hughes is on familiar ground and is as successful as he has been in *April Love* (p.109). The figure of Madeline sitting up in bed, and recoiling slightly from the surprise of finding Porphyro by her, recalls Rossetti's Mary in *Ecce Ancilla Domini! (The Annunciation)* (1849–50). The objects placed on the table by the window, including the Gothic glass and vase, are surprisingly stylised, standing out in white and rendered without the laborious attention to detail that is bestowed on objects in Pre-Raphaelite paintings of the 1850s. The lily in the vase is symbolic of purity and virginity and also an emblem of St Agnes.

In the last panel Hughes shows the lovers tenderly holding hands and rather gingerly stepping over the recumbent porter 'in uneasy sprawl'. The idea for the frame, decorated with painted ivy leaves (like *April Love*), may have originally come from Hunt, who decorated the frame of *The Hireling Shepherd* with ears and sheaves of corn.

Some passages of *The Eve of St Agnes* are painted with Pre-Raphaelite precision, whilst others have a less defined quality, or 'a lack of finish' as the critic John Ruskin expressed it in a review. The colours used – Hughes favoured mauves and greens – are more consistently Pre-Raphaelite.

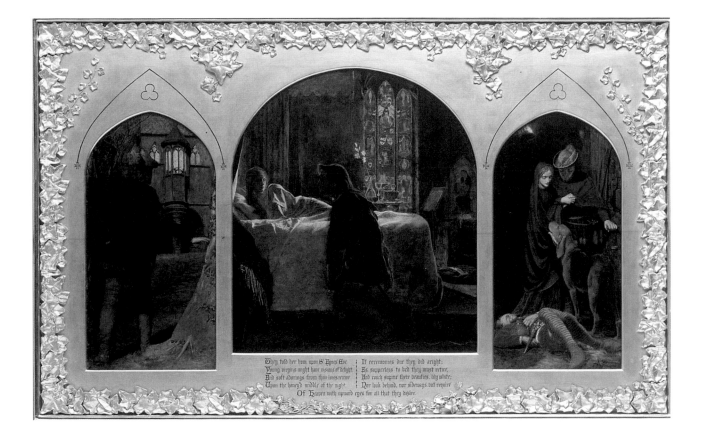

They told her how, upon St. Agnes' Eve If ceremonies due they did aright;
Young virgins might have visions of delight, As, supperless to bed they must retire,
And soft adorings from their loves receive And couch supine their beauties, lily white;
Upon the honey'd middle of the night, Nor look behind, nor sideways, but require
 Of Heaven with upward eyes for all that they desire.

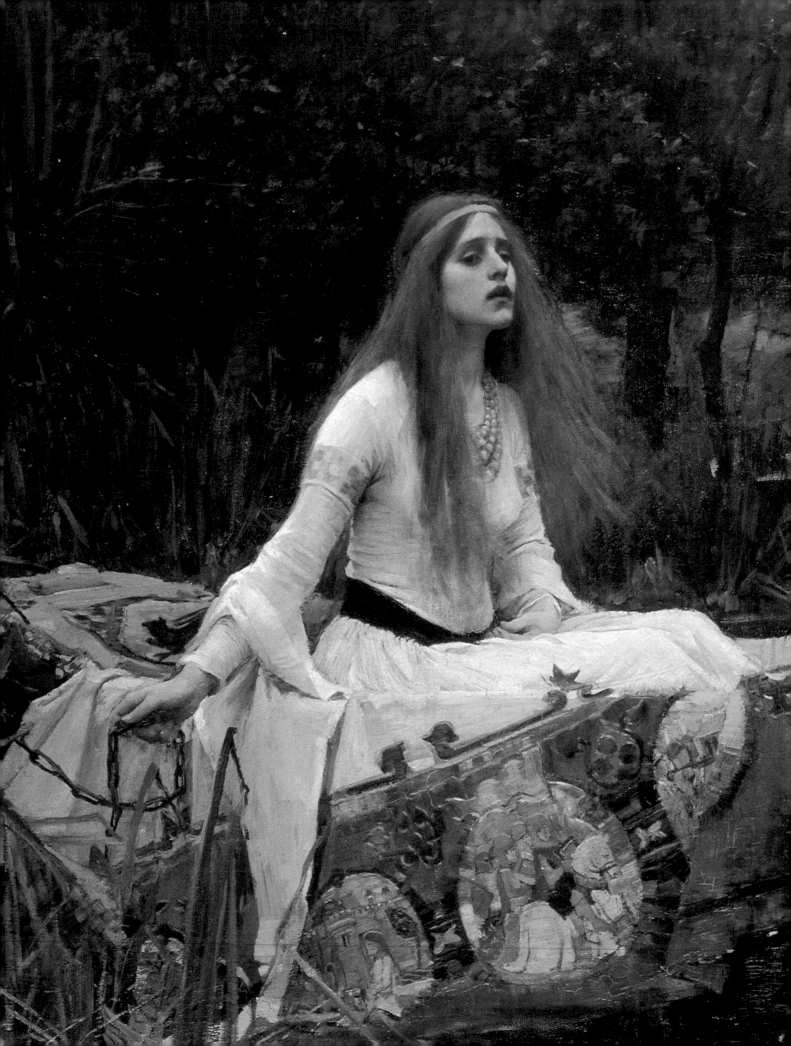

Aftermath

JOHN WILLIAM WATERHOUSE
The Lady of Shalott, detail
(see p.115)

THE Pre-Raphaelite artists had the most immediate and direct influence on the painters of the Symbolist and Aesthetic movements both in England and France. The art of G.F. Watts (1817–1904) in particular echoes the sensualism of Rossetti and Burne-Jones, especially in his poetic studies of his first wife, the beautiful sixteen-year-old actress Ellen Terry. Later followers include John William Waterhouse (1849–1917), whose *Lady of Shalott* (1888; opposite and overleaf) reflects the Pre-Raphaelite passion for Tennyson.

Ruskin had written of Rossetti as 'the chief intellectual force in the establishment of the modern, Romantic school in England'. He influenced both Paul Verlaine, the Symbolist writer, and Claude Debussy, who wrote the cantata *La demoiselle élue* (1888), based on Rossetti's poem, 'The Blessed Damozel' (1850). But there are also later repercussions of his work. The Norwegian Expressionist painter Edvard Munch was influenced by Rossetti when he painted *The Kiss* (1893). It is also arguable that the intensely autobiographical nature of Rossetti's work and his preoccupation with depicting his own lovers prefigure the subjective personality cult in modern art, Picasso being the most obvious exponent.

In 1927 the Bloomsbury art critic Clive Bell reproduced Burne-Jones's *The Golden Stairs* in his book *Landmarks in Nineteenth-Century Painting* as an example of all he disliked in Pre-Raphaelitism, a movement in his opinion of 'utter insignificance in the history of European culture'. Although Bell took an extreme attitude, this view of the Brotherhood as *passé*, in comparison with avant-garde movements in France, became increasingly prevalent. The critic Quentin Bell, son of Clive and Vanessa Bell, who took up the Pre-Raphaelite cause much later, remembered how the Bloomsbury set laughed at the Pre-Raphaelites. To them it seemed that 'everything of importance in the second half of the 19th century had happened in France'.

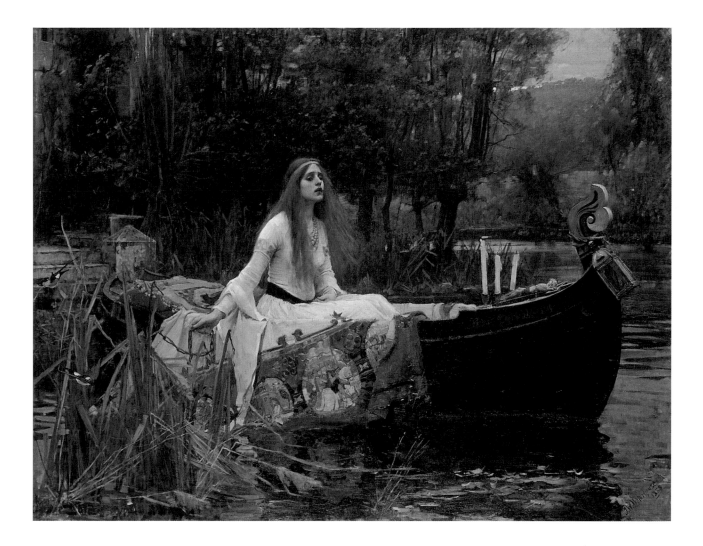

It was not until the 1960s that Victorian painting and furniture began
to be reassessed and gradually to fetch higher prices in the auction rooms.
But as late as 1965 Quentin Bell still found it hard to explain his inter-
est in the Pre-Raphaelites to his friends and colleagues.

By the 1970s the climate had changed, and in 1984 the Tate Gallery's
exhibition *The Pre-Raphaelites* was one of the most popular mounted by
the Gallery, with 200,000 visitors. The idea that French painting was the
only nineteenth-century art of any intrinsic merit had become unfash-
ionable, and a more sympathetic and accurate understanding of the Pre-
Raphaelites' aims, and their desire to escape, has developed. 'I mean by
a picture', Burne-Jones had written, 'a beautiful, romantic dream of some-
thing that never was, never will be – in light better than any light that
ever shone, in a land no one can define or remember, only desire, and
the forms divinely beautiful.'

SELECT BIBLIOGRAPHY

All books published in London unless otherwise stated

Bate, Percy H., *English Pre-Raphaelite Painters, their Associates and Successors*, 1899

Bullen, J.B, *The Pre-Raphaelite Body*, Oxford 1998

Burne-Jones, Georgiana, *Memorials of Edward Burne-Jones*, 2 vols., 1904

Cook, E.T. and Wedderburn, A.D.O. (eds.), *The Works of John Ruskin* (Library Edition), 39 vols., 1902–12

Dodgson Collingwood, Stewart (ed.), *The Life and Letters of Lewis Carroll*, 1898

Doughty, Oswald and Wahl, J.R.(eds.), *Letters of Dante Gabriel Rossetti*, 4 vols., Oxford, 1965–7

Egen, Rodney, *Pre-Raphaelite Prints*, 1995

Fredeman, William E. (ed.), *The P.R.B. Journal: William Michael Rossetti's Diary of the Pre-Raphaelite Brotherhood, 1849–1853*, Oxford, 1975

Fredeman, William E., *Pre-Raphaelitism: A Bibliocritical Study*, Cambridge, Massachusetts, 1965

Gaunt, William, *The Pre-Raphaelite Tragedy*, 1948

Gere, John, *Pre-Raphaelite Drawings*, 1994

Gittings, Robert, *John Keats*, 1968

Harding, John, *The Pre-Raphaelites*, 1971

Hares-Stryker, Carolyn, *An Anthology of Pre-Raphaelite Writings*, Sheffield, 1997

Hilton, Timothy, *The Pre-Raphaelites*, 1970

Hunt, Diana Holman, *My Grandfather: His Wives and Loves*, 1969

Hunt, William Holman, *Pre-Raphaelitism and the Pre-Raphaelite Brotherhoood*, 2 vols., 1905

Hutchison, Sidney C., *The History of the Royal Academy*, 1968

Ironside, Robin and Gere, John, *Pre-Raphaelite Painters*, 1948

Maas, Jeremy, *Victorian Painters*, 1969

Macarthy, Fiona, *William Morris: A Life for Our Time*, 1994

Millais, John Guile, *The Life and Letters of Sir John Everett Millais*, 2 vols., 1899

Nahum, Peter, *Burne-Jones, the Pre-Raphaelites and their Century*, 1989

Newall, Christopher, *Victorian Watercolours*, 1997

Parkes, Kineton, *The Pre-Raphaelite Poets*, 1899

Parris, Leslie (ed.), *The Pre-Raphaelites*, exh. cat., Tate Gallery, 1984

Read, Ben and Barnes, Joanna, *Pre-Raphaelite Sculpture*, 1991

Rose, Andrea, *Pre-Raphaelite Portraits*, 1981

Rose, Andrea, *The Pre-Raphaelites*, 1997

Rossetti, Dante Gabriel, *Dante Gabriel Rossetti: His Family Letters, with a Memoir by W. M. Rossetti*, 1895

Rossetti, William Michael (ed), *Rossetti Papers, 1862–70*, 1903

Ruskin, John, *Academy Notes*, 1855, 1856, 1858

Staley, Allen, *The Pre-Raphaelite Landscape*, Oxford, 1971

Surtees, Virginia (ed.), *The Diary of Ford Madox Brown*, New Haven and London, 1970

Surtees, Virginia (ed.), *The Paintings and Drawings of Dante Gabriel Rossetti (1828–1882)*, 2 vols., Oxford, 1971

Watkinson, Raymond, *Pre-Raphaelite Art and Design*, 1970

Wilton, Andrew and Upstone, Robert (eds.), *The Age of Rossetti, Burne-Jones, and Watts: Symbolism in Britain 1860–1910*, exh. cat., Tate Gallery, 1997

LIST OF PAINTINGS AND DRAWINGS

All works are oil on canvas unless otherwise specified

FORD MADOX BROWN

Carrying Corn 1854–5
oil on mahogany,
19.7 x 27.6cm
Tate Gallery

Chaucer at the Court of Edward III 1851–68
123.2 x 99cm
Tate Gallery

The Last of England 1852–5
82.5 x 75cm
Birmingham Museums and Art Gallery

'The Pretty Baa Lambs' 1851–9
oil on panel, 61 x 76.2cm
Birmingham Museums and Art Gallery

'Take your Son, Sir' ?1851–92
70.5 x 38.1cm
Tate Gallery

Work 1852–63
137 x 197.3cm
Manchester City Art Galleries/Bridgeman Art Library, London/New York

EDWARD COLEY BURNE-JONES

Fair Rosamund and Queen Eleanor 1862
watercolour, 26 x 26.7cm
Tate Gallery

The Golden Stairs 1872–80
269.2 x 116.8cm
Tate Gallery

King Cophetua and the Beggar Maid 1884
293.4 x 135.9cm
Tate Gallery

Sidonia von Bork 1860
watercolour and gouache on paper, 33.3 x 17.1cm
Tate Gallery

GEORGE CLAUSEN

Winter Work 1883–4
77.5 x 92.1cm
Tate Gallery

AUGUSTUS LEOPOLD EGG

Past and Present (Nos 1–3) 1858
63.5 x 76.2cm
Tate Gallery

WILLIAM MAW EGLEY

Omnibus Life in London 1859
44.8 x 41.9cm
Tate Gallery

LUKE FILDES

The Doctor 1891
166.4 x 241.9cm
Tate Gallery

STANHOPE FORBES

The Health of the Bride 1889
152.4 x 200cm
Tate Gallery

WILLIAM POWELL FRITH

The Derby Day 1856–8
101.6 x 223.5cm
Tate Gallery

GEORGE ELGAR HICKS

Woman's Mission: Companion of Manhood 1863
76.2 x 64.1cm
Tate Gallery

ARTHUR HUGHES

April Love 1855–6
88.9 x 49.5cm
Tate Gallery

The Eve of St Agnes 1856
76.2 x 64.1cm
Tate Gallery

WILLIAM HOLMAN HUNT

The Awakening Conscience 1853
76.2 x 55.9cm
Tate Gallery

Claudio and Isabella 1850
77.5 x 45.7cm
Tate Gallery

The Hireling Shepherd 1851–2
76.4 x 109.5cm
© Manchester City Art Galleries

The Light of the World 1851–3
125.5 x 59.8cm
By permission of the Warden and Fellows of Keble College, Oxford

Our English Coasts, 1852 (Strayed Sheep) 1852
43.2 x 58.4cm
Tate Gallery

The Scapegoat 1854–8
33.7 x 45.9cm
© Manchester City Art Galleries

The Shadow of Death 1870–73
33.7 x 45.9cm
© Manchester City Art Galleries

JOHN EVERETT MILLAIS

The Blind Girl 1854–6
82.6 x 62.2cm
Birmingham Museums and Art Gallery

Christ in the House of His Parents ('The Carpenter's Shop') 1849–50
86.4 x 139.7cm
Tate Gallery

Isabella 1848–9
102.9 x 142.9cm
Board of Trustees of the National Museums and Galleries on Merseyside (Walker Art Gallery, Liverpool)

John Ruskin 1853–4
78.7 x 68cm
Private Collection

Ophelia 1851–2
76.2 x 111.8cm
Tate Gallery

The Order of Release, 1746 1852–3
102.9 x 73.7cm
Tate Gallery

The Vale of Rest 1858–9
102.9 x 172.7cm
Tate Gallery

WILLIAM MORRIS

Queen Guinevere 1858
71.8 x 50.2cm
Tate Gallery

RICHARD REDGRAVE

The Governess 1844
91.4 x 71.1cm
Victoria & Albert Museum, London/Bridgeman Art Library, London/New York

DANTE GABRIEL
ROSSETTI

Beata Beatrix c.1864–70
86.4 x 66cm
Tate Gallery

The Beloved ('The Bride')
1865–6
82.5 x 76.2cm
Tate Gallery

*Dante's Vision of Rachel and
Leah* 1855
watercolour on paper,
35.2 x 31.4cm
Tate Gallery

Elizabeth Siddal in a Chair
pencil on paper, 26 x 18.4cm
Tate Gallery

Ford Madox Brown 1852
pencil, 17.1 x 11.4cm
National Portrait Gallery

Found 1854
91.4 x 80cm
Delaware Art Museum,
Wilmington, DE/Bridgeman Art
Library, London/New York

The Girlhood of Mary Virgin
1848–9
83.2 x 65.4cm
Tate Gallery

Proserpine 1873–7
125.1 x 61cm
Tate Gallery

WILLIAM BELL SCOTT

Iron and Coal 1856–61
185.4 x 185.4cm
Wallington Hall,
Northumberland/Bridgeman
Art Library, London/New York

HENRY WALLIS

Death of Chatterton 1855–6
62.2 x 93.3cm
Tate Gallery

JOHN WILLIAM
WATERHOUSE

The Lady of Shalott 1888
153 x 200cm
Tate Gallery

GEORGE FREDERIC
WATTS

Hope c.1885–6
150 x 109cm
Tate Gallery

JAMES ABBOTT MCNEILL
WHISTLER

*Nocturne in Blue and Gold: Old
Battersea Bridge* 1872–5
68.3 x 51.2cm
Tate Gallery

INDEX

Page numbers in *italic* refer to
illustrations